Creating 3D Worlds

Creating
3D Worlds
Simon Danaher

BARRON'S

1	2	3	4	5
Creating 3D worlds	**Terrain**	**Water**	**Atmosphere**	**Celestial objects, Weather, and Effects**
6 Introduction	**20** What is "terrain"?	**48** Simple water planes	**64** Simple sky	**90** Sun
8 Limitations of "ordinary" 3D programs	**22** Displacement terrain	**50** Complex water planes	**66** Creating complex skies manually	**92** Rain (or snow)
10 Types of 3D landscape application	**24** Subpolygon displacement	**54** Simulating wetness	**70** Realistic sky gradients	**94** Lightning
14 Breaking it down	**26** Camera-optimized terrain	**56** Animating ocean waves	**72** Animating a bitmap skydome	**96** Stars and planets
18 The future of 3D landscaping	**30** Optimizing terrain for export	**60** Texturing an animated ocean	**74** Haze, fog, and mist	**98** Storms and tornadoes
	32 Rocks and stones		**76** Volumetric haze	**100** Smoke
	34 Creating distant mountain geometry		**78** Procedural planet clouds	
	38 Floor planes		**80** True volumetric clouds	
	40 Procedural texturing terrain		**84** Realistic planet and atmosphere	
	42 Full-terrain texturing			

6
Populating
Landscapes

7
Lighting

8
Working between
3D applications

9
Interactive
Authoring

106
Simple trees and
plants

108
Procedural trees and
plants

110
Complex trees and
plants

114
Adding creatures

118
Simple man-made
structures

122
Simple lighting—
ambient

124
Realistic scene lighting—
faking radiosity

126
Radiosity rendering

130
Working with lights

132
Special lighting effects

134
Importing objects

138
Compositing 3D
objects

140
Finishing in
Photoshop

146
Landscaping for games

150
Optimizing for
the Web

152
Online resources

153
Glossary

158
Index

160
Acknowledgments

First edition for the United States, its territories
and possessions, and Canada published by
Barron's Educational Series, Inc., 2005

Copyright © 2005 The Ilex Press Limited

This book was conceived by:

I L E X
Cambridge
England

Publisher: Alastair Campbell
Executive Publisher: Sophie Collins
Creative Director: Peter Bridgewater
Managing Editor: Tom Mugridge
Project Editor: Ben Renow-Clarke
Art Director: Tony Seddon
Designer: Alistair Plumb
Junior Designer: Jane Waterhouse

ISBN – 13: 978-0-7641-7843-6
ISBN – 10: 0-7641-7843-1

Library of Congress Catalog Card No.
2004104913

All inquiries should be addressed to:
Barron's Educational Series, Inc.
250 Wireless Boulevard
Hauppauge, New York 11788
www.barronseduc.com

Printed and bound in China

For more information on this title
please visit:
www.web-linked.com/3dwous

9 8 7 6 5 4 3 2 1

Minimum System Requirements for
software on CD:

Mac OSX 10.3 or Windows 2000/XP
1.25GHz CPU G4 or Pentium III
512MB RAM
200MB free hard disk space
Graphics card able to display 1024 x 768 in
65K colors/16 bit
Internet connection and e-mail address

Introduction

Digital 3D graphics have allowed professional artists and hobbyists to create incredible images and animations, and one area of this emerging field of digital expertise is the creation of virtual worlds and environments.

Over the years this has become a very well-defined sector of the 3D digital market and, as a result, there are numerous 3D applications whose sole purpose is to produce 3D imagery of invented (and actual) worlds and places. That said, it's also possible, and in many ways desirable from a professional perspective, to create exterior 3D scenes in a general purpose 3D program such as 3ds max, Lightwave, Cinema 4D, or Maya. This book is dedicated to the techniques and art of creating digital environments in either kind of package, and will examine the different aspects of simulating realistic worlds and landscapes using 3D graphics.

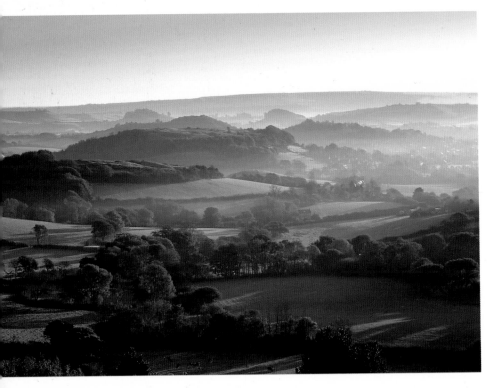

ABOVE AND LEFT *In traditional media, such as photography or watercolor painting, exterior environments have always been a fascinating and endlessly interpretable subject for artists, and in 3D digital media the tradition continues—the difference being that here, artists are creating environments rather than just capturing them.*

OPPOSITE TOP AND RIGHT *An extreme close-up of the ground at the scale of insects is as valid a subject for examination as a large-scale space scene showing most of a planet, but they will require very different approaches technically. Mostly, though, the "environments" covered here will be at the scale of human beings with feet planted firmly on the ground.*

When we talk about "3D worlds" or "virtual environments" we're talking specifically about exterior scenes, such as landscapes, seascapes, and skyscapes, and how to create them in 3D. But environments can also be at vastly different scales.

However, in 3D graphics there are two dominant styles of image: photorealistic and hyperrealistic, both of which we'll look at here. In a photorealistic image the 3D artist will attempt to recreate as faithfully as possible all the natural phenomena associated with exterior scenery and light. With a hyperrealistic image, faithfulness and accuracy need not be a concern. Photorealism can require a battle against the sterility inherent in 3D graphics, while hyperrealistic imagery tends to embrace the character of digital media.

Limitations of "ordinary" 3D programs

Almost any 3D program (except those that are extremely basic) can be used to create a 3D landscape scene. There are three main elements to consider when undertaking such a task: how to create the ground, how to create the sky and atmosphere, and how to light the scene convincingly.

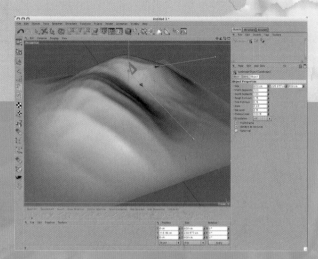

2 Because the object is procedural, you can edit its parameters to change the default mountain into something smoother, such as a gentle rolling hillside.

1 Most professional 3D programs have ways to generate landscapes despite not being specifically designed to tackle such a problem. Here in Cinema 4D, for example, there is a Landscape primitive object that can simply be inserted into the scene.

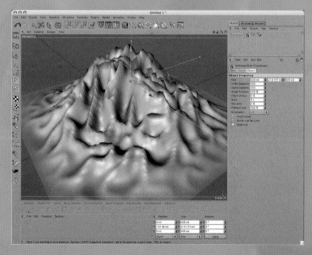

3 By dialing in some higher settings for the fractal pattern that is generating the mountain, you can create a much rougher, craggier look for your mountain. However, when you do this, you notice a limitation of the primitive, and that's its regular polygonal subdivision. Where the frequency and height of the crags is greatest, you can clearly see the polygons that make up the primitive's surface.

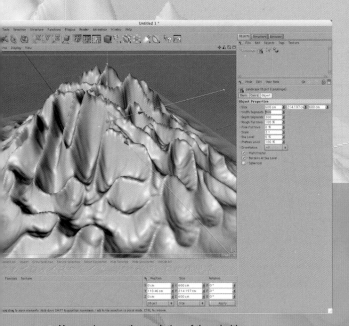

4 You can increase the resolution of the primitive to alleviate the effect of the polygonal artifacts. Here we increased the X and Y subdivision of the primitive from 100 to 300, but the polygons at the peaks are still very much in evidence.

5 Conversely, where a very high density is not required (i.e. on smoother areas toward the edges of the model), the extra polygons are wasted. At 90,000 polygons for this single landscape, it's clear that this is not a very efficient way to work. More polygons makes for slower display and slower rendering.

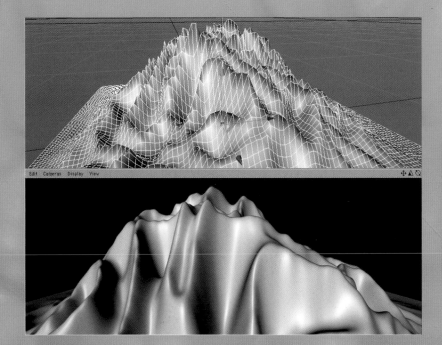

6 Instead of using raw polygon density, we can work around the limitation of the primitive by turning it into a Subdivision Surface object (called HyperNURBS in Cinema 4D). This smooths out the jagged edges when rendered, eliminating the appearance of polygon artifacts. It also keeps the polygon density down to a manageable level when working interactively with the scene. The down side is that you end up with a rather soft and "melted" looking mountain, but texturing can help to counteract that.

Types of 3D landscape application

As we've seen, when using an "ordinary" 3D program, it is perfectly possible to create 3D landscapes, but you tend to have to work harder to overcome the fact that the program is not optimized for that task. There are, of course, a number of programs designed specifically for creating 3D worlds and environments, but these have their own set of compromises that arise from the very fact that they make creating this kind of 3D image easier to produce.

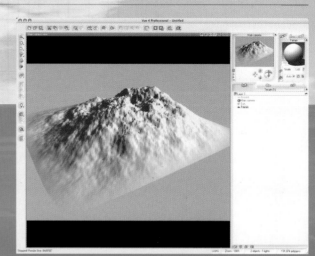

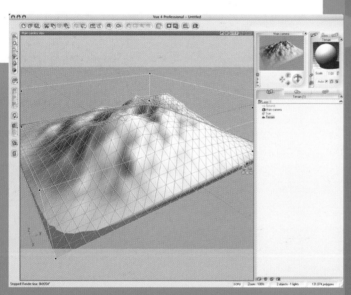

1 One of the most successful 3D landscape applications currently available is Vue. This program is designed with a workflow and toolset specifically for the job of creating landscape scenes. Taking the mountain example once more, we can immediately see a different approach. Landscape objects can be added to the scene, but they seem very low in resolution.

2 Yet when rendered, the resolution is automatically increased to a level suitable for a final quality image. The landscape object is procedural, but separate resolutions are generated for display and rendering automatically, so you don't have to worry about overloading your scene with polygons as you are creating it.

3 That said, there is usually an upper limit to the resolution of a terrain that you define in a system such as Vue because the mountain is generated from a grayscale "height map" of specific pixel dimensions. If you find you need a higher resolution you can increase the map resolution as needed. The program simply resizes the height map. This process is called displacement or height mapping and forms the basis of much landscape work.

4 Here's what's going on internally in a landscape program using displacement maps: a map is generated at a specific resolution, say 256 x 256 pixels square with a fractal pattern. For every pixel, a polygon is created and moved vertically based on the brightness of the pixel. Where there are shades of gray in the map, mountain peaks are generated, but there is zero polygon movement at black pixels.

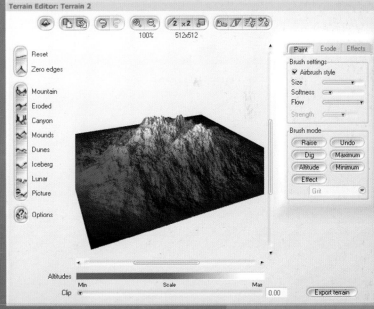

5 So although there appears to be an "increase" in resolution when you render the terrain, it's actually just being rendered at the maximum resolution that is allowed by the height map. To increase the resolution of the terrain when rendered, you need to increase the map size and regenerate the fractal pattern.

Here's another terrain, this time with a 512 x 512 pixel height map. The mountain has finer details because of the greater height map resolution.

Types of 3D landscape application

6 Even though this is a limitation of this kind of terrain generation scheme, it does offer digital artists some degree of control over how to distribute the complexity in their scenes—low resolution terrains can be used in the distance, while higher resolution terrains can be used closer to the camera.

There are other programs that take over the control of resolution decisions; one such application is MojoWorld. In this program, the landscape of an entire planet is generated on the fly procedurally when the camera view changes, and the resolution is set depending on the distance from the camera.

7 Zooming up close to the distant mountains in the previous image reveals complexity and detail that was not generated in the distant view. This approach saves much unnecessary computation, speeds scene interaction, and in animations relieves the artist from having to plan camera paths explicitly and know where to place high-resolution scenery. The problem with this approach is that it also shifts a large portion of the creativity from the artist onto the computer.

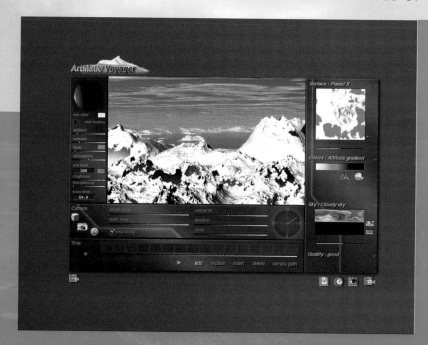

8 In these more automatic landscape applications, rather than building the landscape image from scratch, you set general parameters of the world and then find the vista that you want to render by roaming over it. This kind of exploration method of 3D world-building is more akin to the traditional artist's experience, where you have to go out and find a location that you wish to paint. However, many 3D artists find it unsatisfactory because the chance element inherent in the system makes it impossible to predict the end result.

Another of these exploration renderers is Artmatic Voyager, which takes automatic 3D landscape rendering to the level of total convenience, zero effort. It has a simple interface that allows you to alter certain parameters of the world such as sun direction, land texture gradient, and atmospheric conditions, and renders the scene interactively as you change the camera view.

9 Although ArtMatic Voyager is great for creating 3D landscape images and animations in a hurry, it's not exactly the last word in offering you artistic expression. For that, like any artistic discipline, you need to do the legwork yourself.

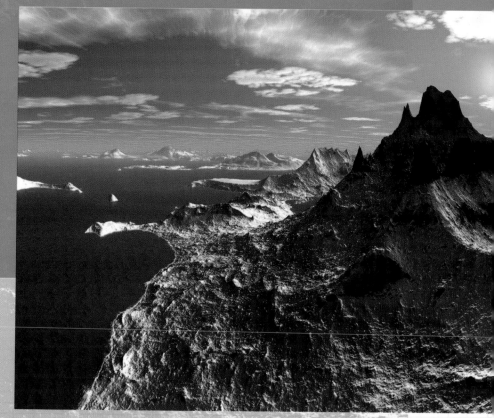

Breaking it down

Broadly speaking, there are four main aspects to a 3D environment: geometry, backdrop, lighting, and atmospherics. These four aspects apply to most kinds of exterior environments, be they landscapes, seascapes, or some other kind of vista.

 Geometry is used to create the land, sea, or other kinds of structure in the scene, natural or man-made. The most common example is what is known as a terrain—the land in a landscape. As we saw earlier in this chapter, terrain can be created in different ways depending on the kind of program that you are using, but no matter how it is created, it's the solid stuff that makes up the majority of most environmental scenes.

1 The bulk of "land" in a landscape is made up of geometry objects. In this example, there is no land, but the sea surface is still a geometry object made of polygons.

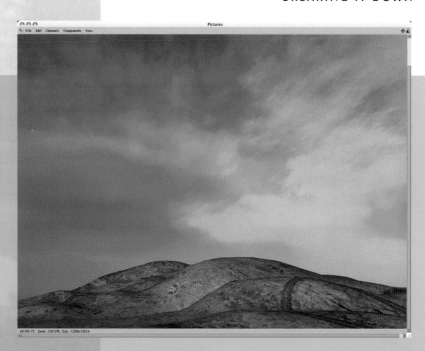

2 Backdrops (or backgrounds) are a very efficient way of creating the sky in an exterior 3D scene. A backdrop is simply a texture map applied either as a post-render process, in a compositing application, such as Photoshop or After Effects, or onto a special backdrop "sky" object in the 3D scene.

A sky object is usually a very large sphere surrounding the scene, whose surface normals point inward so that the inner surface will render. Texture maps of photographic sky images can be applied to the sphere to create the illusion of realistic sky.

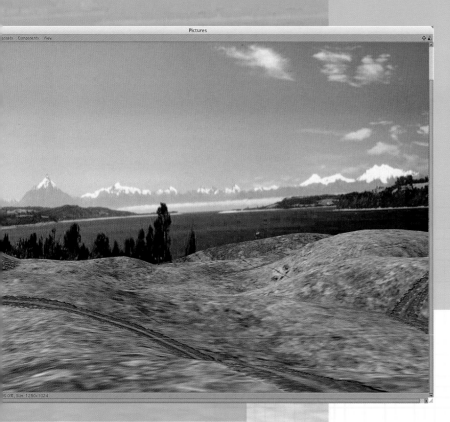

3 Backdrops can also be useful for adding very distant objects that are far enough away that parallax effects (where near objects appear to move faster than far objects when you're traveling) can be disregarded. Examples might be the sun, moon, or other celestial objects, but even distant mountain ranges can be added as simple backgrounds if the foreground objects are close enough to the camera, or if the camera does not move much in an animation.

For stills, you have even more freedom in deciding which objects to model as geometry and which to "paint" on the background. However, as seen in this example, using a JPEG photo can result in a poor image because of compression artifacts. It's always best to use lightly compressed or uncompressed images if possible to prevent such artifacts appearing.

Breaking it down

Lighting is a broad term used to cover basic scene illumination, such as sunlight. Special lighting cases include volumetric rendering effects, which can add a great deal of realism but can be computationally expensive. Volumetric effects include sun beams, fog, and even entire skyscapes. When recreating exterior lighting, you also need to take the effects of the direct illumination (e.g., from the sun) and the indirect, ambient illumination that is produced by the sky dome itself into account.

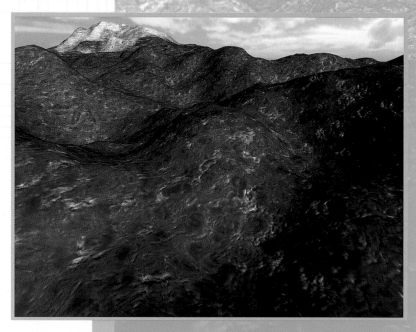

4 Direct illumination from a distant light emulates the sun, but the results obtained with a single light source will often produce dark edges on the geometry. The parts of the scene that are not in direct illumination by the light source are rendered black, but this is not what happens in reality.

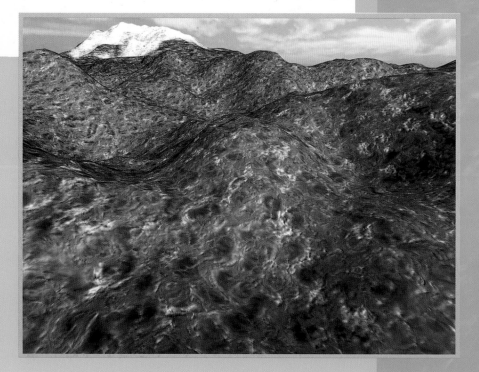

5 Special techniques can be used to brighten up these shadow areas, and we'll look at this in more detail in Chapter 7. Here, global illumination rendering takes into account the diffused illumination from the sky, producing a much softer, evenly lit image that doesn't have those harsh black shadow areas. Note that this scene, with its simple geometry and texture, makes for a very monotonous image—with this more even lighting, produced with high ambient light levels, you tend to have to add more interesting detail using textures or geometry.

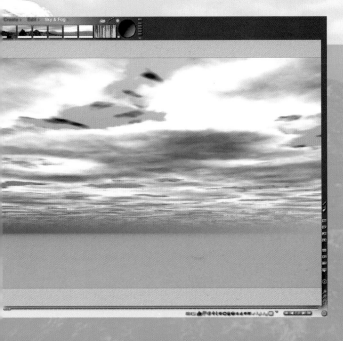

6 Clouds are an important part of any exterior environment, and different 3D applications produce them in different ways. The most common method is to use procedural fractal textures applied to infinite cloud planes, as illustrated here in Bryce. Sky planes are acceptable, but they are no match for true volumetric clouds, which have height and thickness. If you want to go for a more computer-generated (CGI) look, then cloud planes serve their purpose.

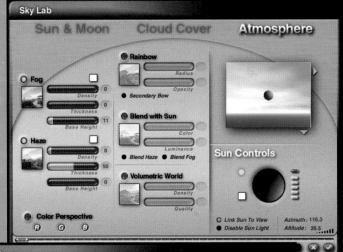

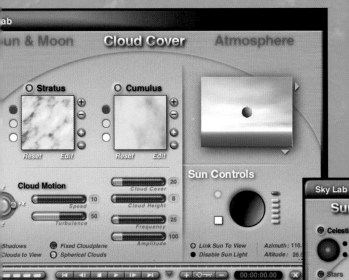

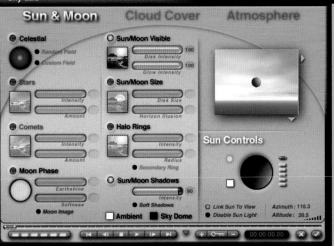

7 Many landscape applications roll the background and atmospheric attributes into a single feature or interface where you control everything that is not geometrical. There will often still be individual parameters for each attribute such as the level of haze and cloud cover and type, but it's worth mentally separating the attributes of the sky into background and atmosphere even if the program itself doesn't. Here in Bryce 5, the Sky Lab contains all of the controls for backdrop and atmospherics, as well as for the lighting. Each section has its own panel to make things easier.

The future of 3D landscaping

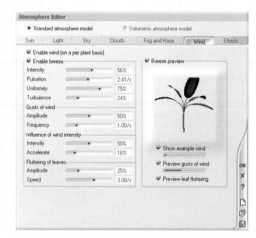

The interface for Vue's Atmosphere Editor
Vue's breeze effects add automatic animation detail to plants

I decided to put the question of where the future of 3D landscaping programs is heading to a developer, to get an insider's view of the subject. Here's what Nicolas Phelps, CEO of E-on Software, developers of the Vue range of 3D environment rendering applications, has to say on the matter.

"I remember, back in 1992, showing a friend a picture created with a very first version of Vue; he believed me when I said it was a photo from the south of Italy! Of course, at that time, I was very proud! But, according to today's standards, the picture was so crude that it now makes me laugh just to think about it: the amount of ground that has been covered in just 12 years is simply amazing. Yet, as the power of our hardware keeps soaring, software developers keep finding new ways to use that power; it will soon be impossible to distinguish a good rendered picture from a real photo. This increase in computer power will translate into faster render times, but also into richer, more easily handled environments. The quality of the rendering algorithms used in modern 3D applications is already on the verge of perfection. However, achieving photorealistic results still implies a lot of work going into the details of a 3D scene, as well as necessarily compromising on that level

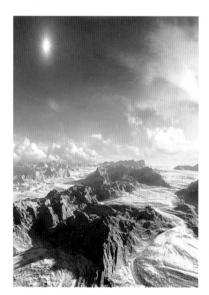

rising star robert czarny
Procedural fractal terrain offers infinite detail

cerro verde eran dinur
Vue's EcoSystem technology lets you create millions of plants automatically

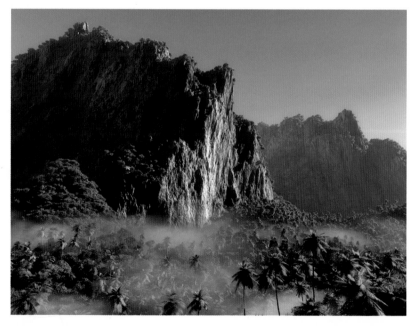

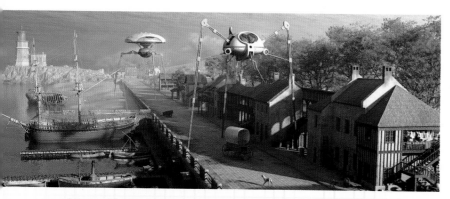

war of the worlds robert czarny

venus robert czarny

tropical cove luigi marini

bali eran dinur

of detail. This compromise is required because of the current limitations of our computers, and also because of the sheer amount of time involved in the creation of these details. Applications like Vue already push the envelope of 3D creation very far by allowing artists to create the lesser details of their scenes algorithmically, both in terms of geometric and animation detail. E-on Software's EcoSystem technology, in the way it allows users to create millions of plants by acting on a few high-level parameters, is a good example of the automatic creation of geometric details that modern software is capable of. Conversely, because of the way they add automatic detailed movement to the leaves of all the plants in a scene, Vue's breeze effects would be the equivalent example in terms of automated animation detail. The coming years will see this tendency confirmed, with, on one hand, the automated creation of microscopic details, and on the other hand, the increased ability to interact with that environment at a macroscopic level. Ultimately, the artist will be able to concentrate more time on the truly creative process, while letting the software take care of the lesser details."

Founded in 1997, E-on Software was established to develop and promote the highest quality graphics tools with professional strength features, specializing in the natural world. Established by graphics enthusiasts for graphics enthusiasts, E-on Software translates its passion for art into tools for the graphics community. E-on Software has offices in Beaverton, Oregon, and Paris, France. The company has achieved a worldwide reputation for its award-winning 3D scenery generator Vue Professional.

What is "terrain"?

Terrain is a general term for any land geometry that you create in your 3D environment, but it also has a narrower meaning that is specific to 3D landscape modeling programs. Most general-purpose 3D programs, such as Lightwave, Maya, and XSI, don't specifically have landscape primitives, so the term "terrain" is often used to describe the primitives in dedicated landscaping applications that create the ground, mountains, and hills.

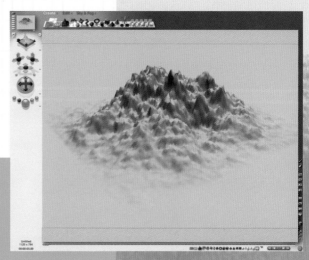

2 When the terrain is rendered, you can see that it is a plain polygonal object, and that it's a little too coarse for its intended use as a landscape. Terrain objects such as this usually arrive in the scene in a default state, and it's up to you to customize it to suit your needs so that you end up with a personalized image.

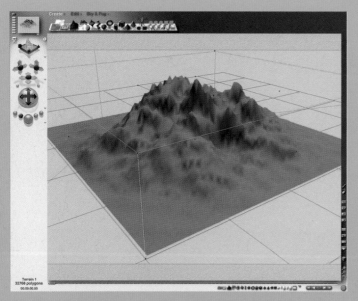

1 You can make mountains and other landscape objects in any decent 3D program by using displacement mapping, but in dedicated 3D landscape applications, such as Bryce, there are terrain objects ready for you to use. Here is a simple terrain added to a scene in Bryce.

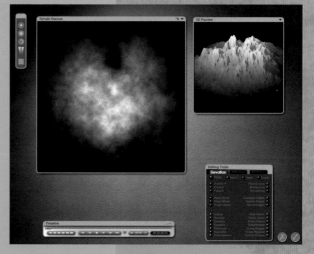

3 In Bryce, as in many other landscape applications, terrains are generated using height maps. These are grayscale images whose pixel brightnesses defines the degree of polygon displacement of the final mesh, which is just a flat plane initially. Bryce's terrain editing interface lets you see the height map and the geometry that results from it all at one time, which makes it easier to understand what's going on.

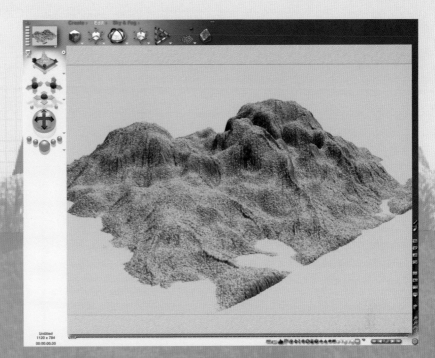

4 When added, the terrain object has a low resolution of 128 x 128 pixels, resulting in a mountain with polygon edges that are clearly visible. You can increase the resolution of the height map in the Terrain Editor to create a denser mesh and therefore a mountain with much finer details.

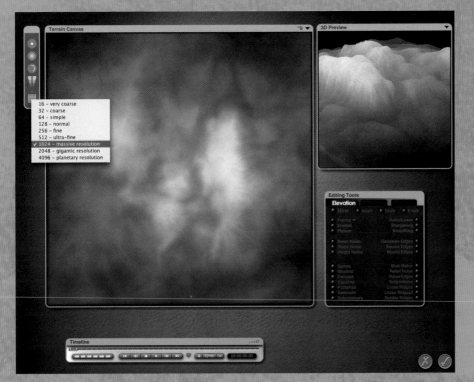

5 After resizing the height map, you need to regenerate the fractal pattern to make best use of the increased resolution. This necessarily changes the look of the mountain because the fractals are all unique. With some further editing, such as adding erosion and some noise, the resulting object is much more detailed.

Displacement terrain

As we've seen, all of the dedicated landscape applications allow you to create terrains automatically, and to modify them to some degree. This is fine if you don't need to have absolute control over the terrain, but if you do, then the editing tools can be difficult and the process of getting the result that you're after can be a long one. Thankfully, you can create a mountain in any 3D program that uses displacement mapping. It's often much easier to work in a "normal" 3D program because the toolset is much richer and will offer more control, though at the expense of ease of use. The process is actually very similar technically; it's just that you are creating the entire effect by hand rather than letting the computer generate it.

1 This is a grayscale height map that was created in a landscape generation program. The image is exported and saved as a TIFF to be used in our 3D application.

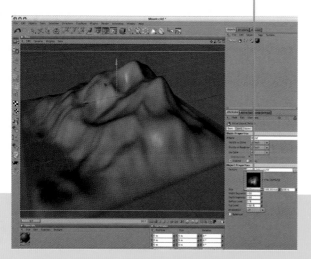

2 In Cinema 4D, we create a special relief object. This is a flat, highly meshed plane that can use an image as a displacement map. You could use a normal plane and apply a displacement material to it, but the relief object can be previewed on the screen, whereas a displacement material is only visible when rendered. The mountain texture is loaded in to the relief object.

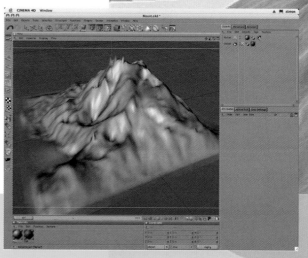

3 The relief object can be converted into a polygon mesh and edited like any other. Here we used the Magnet tool in Cinema 4D to push and pull on the mesh to change its shape and add some spikes and detail.

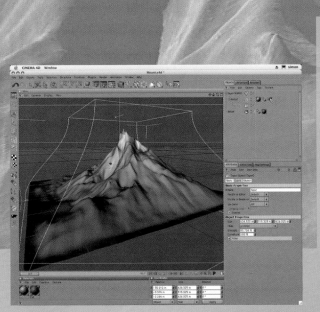

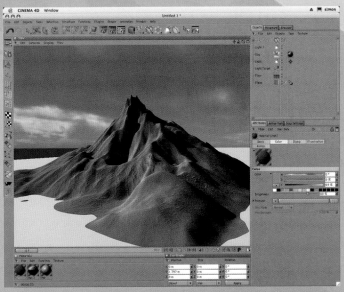

4 Because it's now a polygon mesh, we can also deform it. Here a taper deformer has been added to make the mountain pointier and a little more dramatically sculpted. The mesh can then be subdivided using HyperNURBS (Subdivision Surface smoothing) to prevent any jagged edges.

5 Add a bump map, a sky, and some light, and we're ready to test-render the mountain. As you can see, the result is far more personalized than the generic mountains that you tend to get from landscape rendering applications.

Subpolygon displacement

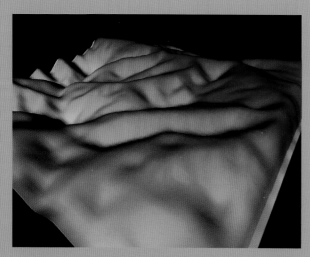

One recent trend in high-end 3D graphics is subpolygon displacement (SPD, also known as subpixel displacement). This is an advanced rendering technique that allows you to create immense levels of detail within a model without the overhead of creating extra polygons in the scene itself. SPD uses the same principle as displacement mapping and bump mapping, using a texture to create surface relief, but does so at render time only and at much higher mesh resolutions.

1 Without subpolygon displacement, a displaced mesh can look a little soft and lacking the fine details found in reality. Much of this can be faked using bump and texture maps, but these, too, fail if you get too close to the object.

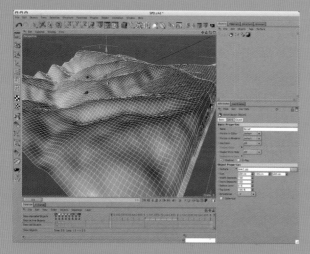

2 Here's the wireframe. You can see the polygon density involved. You could easily increase the in-scene resolution, but that would make interaction with the scene more difficult. Using another method such as Subdivision Surfaces is an alternative, but they tend to smooth out details even further.

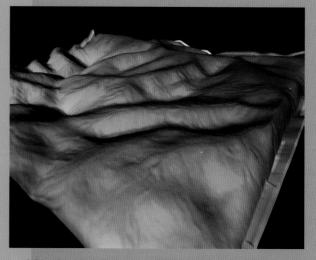

3 With subpolygon displacement (SPD) enabled, using a single subdivision level and a high-resolution height map, the details in the map become more clearly defined. The software generates extra polygons based on the height map during rendering only.

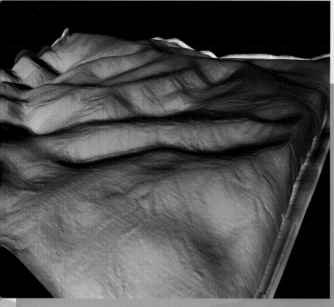

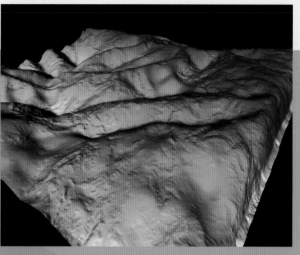

4 With four times SPD subdivision, so many polygons are generated that the height map itself becomes an issue. The polygons are clearly outlining JPEG artifacts in the map, and this is a problem when using SPD. You must have a very high-resolution, very clean height map to get the best results.

5 In this render, we have gone back to 1x SPD using the height map but added a second layer of SPD that uses a procedural fractal noise pattern. Because the fractal is procedural, it too is generated at render time at the resolution required. This produces the effect of added detail without any worries about artifacts or pixels becoming visible in the displacement. Note that all of the detail in this render is being produced with geometry, not bump mapping.

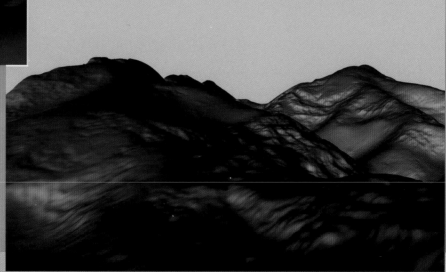

6 Because of the massive resolution that is generated, you can move in close to the landscape and not see any polygons. This is particularly noticeable at the edges of the mesh, which would normally exhibit choppiness; however, they display a great deal of detail here. Adding texture and bump detail to this base mesh is all that's required to turn this into a competent landscape.

Camera-optimized terrain

Creating still images is one thing, but if you want to animate your camera to create a movie of your environment, things can become very complicated. One of the main difficulties is maintaining an efficient scene that is easy to work with while also having the detail in the final render. Using traditional techniques, you would need to plan exactly where and how the camera would move through the scene, and then set up the terrain objects so that those close to the camera as it passes have the most detail and resolution, while those farther away are less detailed to conserve memory and other system resources.

An alternative is to create camera-optimized terrain, which is generated as it is needed. When the camera isn't looking in a particular direction, no terrain is generated there. It sounds like a complicated job, or perhaps more like a plugin, but in fact it's quite straightforward to set up in most 3D animation systems. The only requirement is that textures can be applied in world coordinate space.

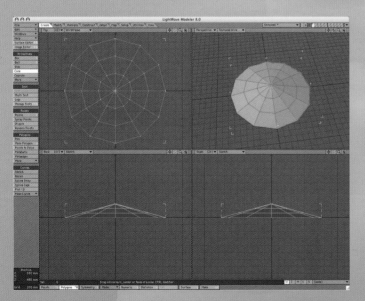

1 To begin with, you need some geometry, so, using LightWave in this case, we create a 12-sided cone that is subdivided three times in its height. It doesn't matter how high it is, but in LightWave you have to give it a little height in order to get subdivisions there.

2 Next, all except a small fan of 12 polygons are deleted. This wedge-shaped geometry needs to be this shape because it will fill the cone-shaped field of view of the camera. The rest of the cone including the base polygon will never be seen and so can be safely deleted.

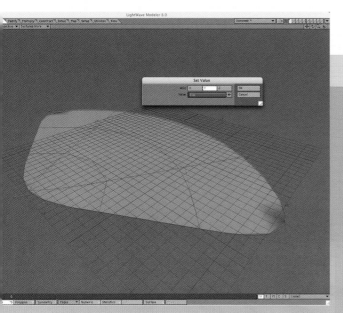

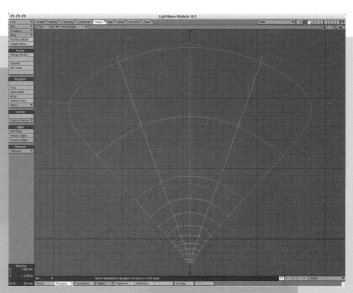

3 This object is converted to a SubPatch object by pressing the Tab key. Because the subpatch shrinks slightly, you need to move it down a little so that the visible geometry starts at the world origin point (0,0,0). The Set Value command is then used to flatten the fan to the ground plane.

4 The terrain fan is further adjusted by subdividing the first row of polygons using the Knife tool to increase the polygon resolution closest to the camera. This gives us the resolution gradient that will help further optimize the scene.

5 Once modeled, the terrain fan can be loaded into Layout, the animation and rendering part of LightWave. Here the camera is positioned above the fan and pointed slightly down at it. The fan object can then be scaled up so that the far edge is sufficiently distant.

Camera-optimized terrain

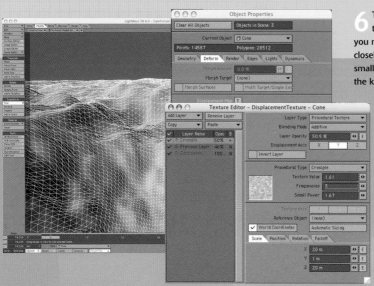

6 The displacement texture is applied to the fan to give the terrain topography as you normally would do. However, if you look closely at the texture dialog, you'll notice a small option called World Coordinates. This is the key to the effect.

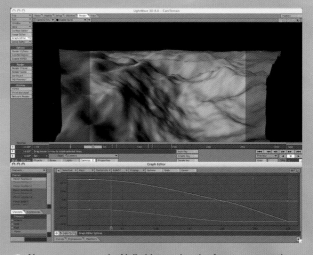

7 When World Coordinates is enabled for a texture, it is applied in world space as opposed to object space. A texture applied in object space stays fixed to the object if the object moves. When you move an object with a world space texture applied, the texture stays put and the object appears to move through the texture. In order for this to work for our scene, we need to connect the camera and terrain object together so that they move as one. To do this, we add a Null object and make the terrain fan and camera children of it.

8 Now we can move the Null object and set keyframes to move the camera and the terrain as one. Remember that the texture will stay locked to world space, so as the terrain moves it will actually look as though the camera is flying over an infinite landscape. In fact it is infinite, you can render an animation for hours and the landscape would never end. You can see an example movie on the CD, CamMoveSOR.mov.

9 The beauty of this rig is that the viewpoint is totally free. You can move and pan 360 degrees in any direction, but you need to be careful how you do it. The camera can be rotated in pitch and bank, but not heading; otherwise, the edges of the terrain will become visible.

10 To change heading (look left and right), you must rotate the Null object so that both the camera and the terrain move together. This keeps the terrain locked to the camera's viewpoint, though the texture will of course still appear to move. What you mustn't do is rotate the Null object in pitch or bank because that will cause the texture to move vertically through the terrain, making the landscape appear to morph into a different topography.

Optimizing terrain for export

Another optimization situation occurs if you need to export a terrain object from a dedicated landscape application like Bryce into a standard 3D program. This is a useful option, as it allows you to model using a dedicated 3D landscaping toolset and then animate and render using more sophisticated tools elsewhere.

2 The Export dialog displays the polygon terrain object in a shaded view allowing you to assess the quality before exporting. Here you can also modify and optimize the resolution of the mesh to get the best balance between detail and efficiency.

1 You can export a terrain object from Bryce into another 3D program for inclusion into a project. All you need to do is select the terrain and then choose File > Export Object from the main menu.

3 Switching to wireframe mode allows you to see the mesh that is to be exported. The large slider at the bottom lets you choose the desired resolution, from low to full resolution.

4 This is fine for basic optimization, but the best option is lurking in the small triangle above the slider. Here you can change the mesh generation mode from a regular grid to Adaptive. In Adaptive mode, you can still use the slider, but the software automatically reduces the resolution in areas where the terrain is flatter and the polygons less perturbed, such as at the edges of the object.

5 You can also export texture maps generated from the procedural textures in Bryce, which is also handy. You can set the resolution of the maps from a menu, and it's usually best to use a higher resolution than is set by default.

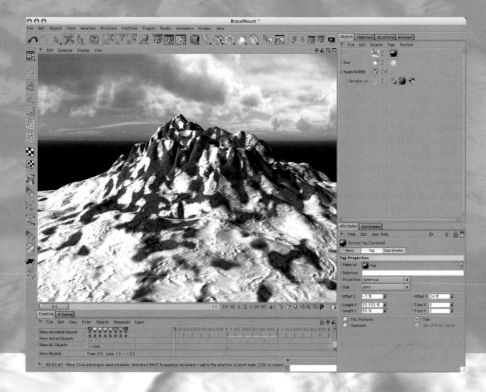

6 The mesh is exported in 3DS (3D Studio) format, which most 3D programs can open. Here's the finished, optimized mountain imported into Cinema 4D, lit, retextured, and rendered.

Rocks and stones

Rocks and stones may seem trivial, but they can add an awful lot of detail and realism to a landscape. They are also useful compositional tools, and the odd carefully positioned rock can work wonders for balancing a composition. Because rocks and stones come in all shapes, it's actually quite difficult to model them. Part of the problem is making them so that they look random, but not too random, and not CGI-looking. If they're too round, they look like beach pebbles, but if they are too random and rough, they just look wrong. It's also important for photorealistic scenes to get the right type of rock for the landscape you are producing, and that might involve a little Internet research. This can seem like overkill for just a few stones, but it can make a world of difference in your scene.

2 Next, the polygon is extruded upward to give the rock volume. We have also rotated the extruded face to begin the process of creating the rough irregularity that defines a rock's appearance. We'll also start creating some variation on the rock at this stage to save having to do too much when the rock becomes more complicated.

1 If your 3D program doesn't have a rock generator primitive (and even if it does), you can build custom rocks and stones using ordinary polygon tools. Here we begin building a stone by creating an initial polygon. It's an irregular n-gon that's roughly the shape that we want. An n-gon is any polygon that is made of more than four points, where n is the number of points. Most 3D programs triangulate n-gons during rendering to prevent the shading artifacts that can be caused by nonplanar polygon faces.

3 The polygon object can then be converted into a Subdivision Surface (HyperNURBS in Cinema 4D, SubPatches in LightWave, a Polygon Proxy object in Maya, and a Mesh Smooth modifier in 3ds max; they basically do the same thing and that is to smoothly subdivide the mesh). This creates a pebble-like stone useful for a beach or river scene. A copy of this object can be saved as it is, see the file Pebble.c4d on the CD.

4 Alternatively, broken stones that have not been eroded by the weather or flowing water will not have any smooth surfaces, so we need to model the many jagged faces that these rocks posses. A quick and easy way to add the roughness and cleaved faces is to use the Knife tool to cut through the rock object a number of times at different angles.

5 Done cleanly, you will have a series of new edge loops that can be selected and scaled, rotated, or moved to get a more organic, rough look. This rock can be saved out separately too, it's useful for distant positioning, see PolyRock.c4d on the CD.

6 The rock still has a roughly convex shape, making it still look a little contrived. By extruding a few faces, you can add parts that jut out from the main volume and then create convex sections of the surface. This will also help to make the rock less identifiable if you make duplicates of it in your scene.

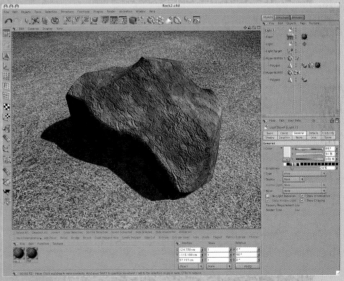

7 Adding a rock texture and bump map finishes the object off. If you want a jagged, fresh rock, then leave it totally polygonal. Here we've converted into a Subdivision Surface object to create a softer, more weathered look. Using edge weighting, we can increase the hardness of selected edges to prevent the rock from looking too soft. See Rock fin.c4d on the CD.

Creating distant mountain geometry

We mentioned previously that, in many cases, especially where the main focus of an image or animation is in the near foreground, a photographic backdrop can be used to simulate distant terrains and other landscape elements quickly. However, in some cases, you will need to create actual geometry instead. This will be necessary if during an animation the camera moves a significant distance toward the distant landscape, or if parallax effects become important. You might simply want to build a distant mountain range because you don't have a suitable image for the background, or if the image you are using does not look right for whatever reason.

1 We'll use LightWave for this example, but the technique is transferable to most 3D programs. We begin by creating a long, flat polygon object, subdivided into equal parts, using the Box tool in LightWave.

2 Using the Bend tool, the polygon object is bent into an 180 degree arc to make a semicircle. This will provide a partially encompassing mountain range allowing a fair degree of camera movement, though you could easily create a totally circular polygon band for 360 degree panoramas. This object is then converted to SubPatches.

3 The object is repositioned and rotated so that its pivot point is at the origin. Because the bending process tends to thin out the polygon, in this step the rear two rows of points are selected and scaled uniformly to add some extra depth.

4 Because we'll use displacement mapping to create the terrain, we need to be able to control the point displacement, zeroing it out at the front and rear edges and the ends or it'll look more like a sheet billowing in the wind than a solid mountain. In LightWave, the easiest way to do this is to create a weight map. Here the center row of points will be the peaks of the mountains so these are given a weight of 100% (red) while the edges are set to minus 100% (blue).

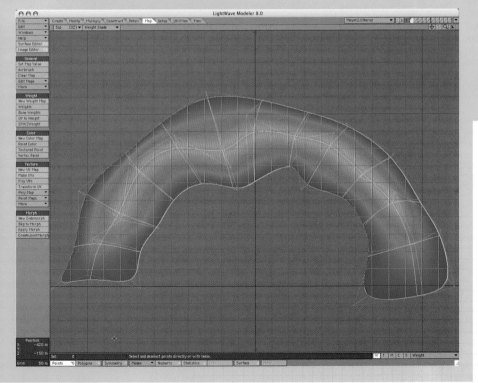

5 To add a little extra randomness to the mountain range we can jitter the points along the Z- and X-axes as shown here, though it'd work just as well as it was. The final step is to scale the object so it is many miles in size.

Creating distant mountain geometry

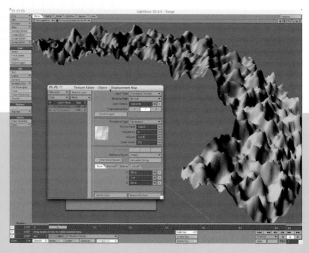

6 The mountain range object is loaded into Layout, the rendering section of LightWave. LightWave's scene units will need to be reset back to 1m because it autoscales, and we want the mountain to stay huge.

7 Now we can add a displacement texture to the mountain using a fractal noise pattern. Without using the weight map, this is what you get. Notice that the fractal pattern covers the whole of the object evenly, and does not look real.

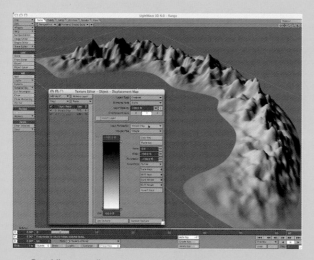

8 By adding a gradient texture as an alpha mask for the fractal pattern and setting its mode so that it uses the weight map that we created earlier, we create the desired falloff of the fractal pattern at the edges of the object.

9 We can animate the camera to move across the scene and introduce a floor and some foreground objects to get a better idea of the parallax involved. As the camera moves laterally, the telegraph poles move normally as expected, but the distant terrain object only moves a little across the frame. The large parallax effect between the poles and the mountain range is what gives the visual cue necessary to create the feeling of distance and scale. See the movie RangeMov.mov on the CD.

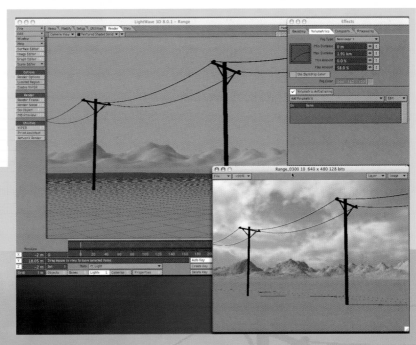

10 A little fog in the scene helps to add a greater sense of distance, simulating atmospheric haze. Different applications handle this effect differently, and we'll look more closely at that in Chapter 4.

11 There's nothing preventing you from animating the camera right up to the mountain range in a dramatic flyby. Because we've modeled the mountains to scale (roughly anyway), the effect should hold together. The mountains are saved as a mesh object on the CD in LightWave and 3ds max formats, Mount.lwo and Mount.3ds.

Floor planes

Occasionally you will want to render a
landscape scene that incorporates a large
flat area of ground, such as a field, a plain,
a plateau, or even a man-made surface like
tarmac. In all cases, you'll come up against
one of the main difficulties in texturing—that
of repeating texture patterns. Ideally you want
a floor texture to cover the whole floor as far
as possible, but without the texture appearing
to repeat itself. However, this can be more
difficult than it first seems.

2 That is, it covers it until the camera angle drops to reveal more of the
floor. As the horizon becomes visible, so does the fact that the texture is
repeating as the floor stretches into the distance. In this case the floor object is
an infinite plane, and a finite texture simply will not cover it without some kind
of patterning appearing as the frequency of the texture increases.

1 When you apply a texture map to a plane, it can look
fine if only a small and finite area is seen by the camera,
as in this case. This texture map is 1024 x 1024 pixels in size
and covers the area nicely.

3 MIP (multum in parvo) and SAT (summed area tables) mapping help to
reduce noise on distant textures, but patterning can still be problematic,
as we've seen. An alternative is to use a procedural texture that, theoretically
at least, is infinite and so doesn't repeat as can be seen in this image.

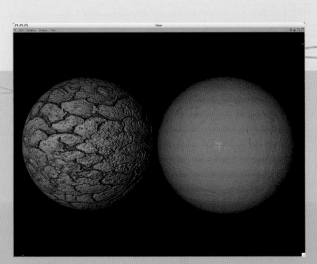

4 However, fractal textures tend to lack the realism that's required for photorealistic rendering in such situations, so it would be ideal if there were some way to combine the two. Well, there is, and it's quite simple. Two materials are created (or texture layers in a single material, depending how your 3D program works)—one using an image and the other using a roughly similar fractal noise.

5 The materials are applied to the ground plane, but the image-mapped texture is set to fade out using a Fresnel shader—in Cinema 4D it's placed in the material's Alpha channel. If you're doing this in a single material, then the Fresnel shader can be applied as a mask. The floor nearest the camera will display the texture, while the distant areas will show the fractal noise. You need to adjust the Fresnel shader to get the best blend between the two.

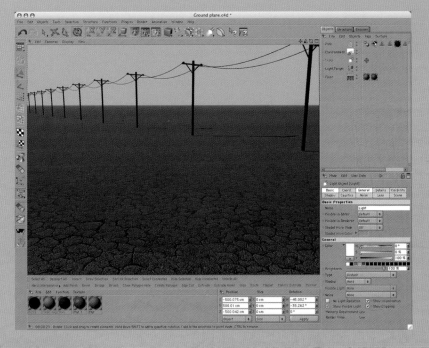

6 Add some distant fog to mask the MIP smoothing of the noise in the distance and a few objects to draw focus, and the scene really starts to come together—a floor plane texture that doesn't have a patterning problem. The limitation of this technique is that you can't move the camera away from the ground plane too far or you'll see patterning again.

Procedural texturing terrain

In most 3D programs, especially dedicated landscape applications, bitmap texturing of landscapes and its pitfalls can be avoided entirely by using procedural textures, also known as shaders. A procedural texture, unlike a bitmap, is calculated by the software during rendering, and is therefore resolution independent. You can zoom into a procedural texture as close as you like and never see the pixels that it's made up of because the texture is regenerated at each zoom level. Fractal noise is a common source for procedural textures, and there are many different variations of random fractal patterns that are useful for texturing all kinds of objects, especially terrain.

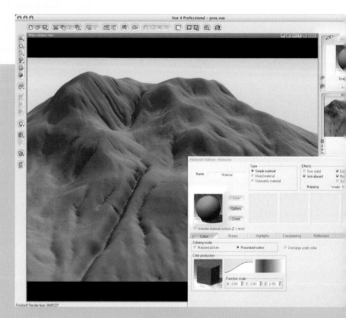

1 Here's a mountain that has been generated in the landscape rendering program Vue. At the moment, it only has a simple flat gray texture applied to it, but we can add procedural textures to create the detail that we want.

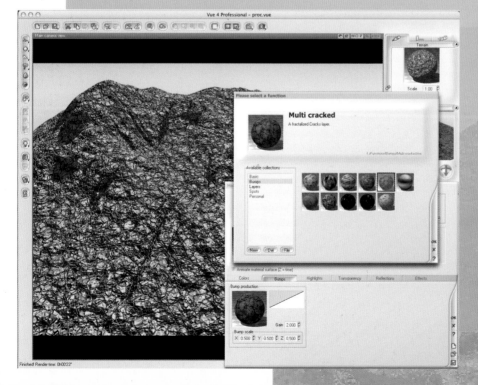

2 First, a fractal noise pattern is used in the bump channel of the material to create surface roughness on the rock. Vue has more complex procedural shaders than a normal 3D program, and these are better at simulating natural materials such as stone, rock, mud, and grass. We can simply choose a procedural bump map we like the look of and use that.

3 The ability to mix and blend materials is present in most 3D applications. In landscape programs, you will often have mixing controls specific to terrain, such as altitude and slope. Here, a new material that features its own color and bump shaders is added to the terrain, but the blending is uniform so it doesn't look good at all.

4 By introducing altitude-dependent mixing of the two materials, we can control the distribution of the one material over the other. Sliding the altitude-dependent control toward maximum reduces the appearance of the grassy texture the further up the mountain you go. A slope control does the same thing except it reduces the opacity of the second texture depending on the steepness of the terrain surface. Where it is flatter, you get more grass; where it is steep, more rock. The controls are interreactive so you do need to play with them a little and do test renders to get the best result. This file can be found on the CD as Proc.vue.

Full terrain texturing

Texturing terrain is as important to the final look of the scene as modeling. Many of the fine details that make a terrain look convincing come from the texture map, and the color and bump maps are most important. Texturing using bitmap images has advantages over procedural texturing because you can use photographic detail to add realism to your 3D model rather than attempt to recreate this detail from scratch. The Internet is a good source of images, but you can also take your own using a digital camera. A good 2D editing program such as Adobe Photoshop is a great bonus here because you will undoubtedly be combining two or more images into the final color and bump maps to create the final texture. Hand painting detail can also work well, but if you do download images from the Internet, make sure that you have permission to use them from the copyright holder. Combining procedurals and bitmaps often yields excellent results, and we'll look at using both to create a full mountain texture here.

1 We'll create a texture for a high mountain range using bitmaps for the bulk of the detail. We'll break down the texture into a number of layers—first is the rock that will be visible toward the top of the peaks as the soil and foliage disappear. Here we have a collection of images that we've gathered to make the stone texture.

2 An image of some rough dirt is opened in Photoshop and dragged into a file at a size of 2048 x 2048 pixels. Sometimes you might need an even larger texture map in order to get fine details on such a large object. The Pattern Maker filter is used to increase the spread of the smaller dirt image over the whole of the new texture. This is saved as a new TIFF image file.

3 This material is used in the color and bump channels of a new material back in the 3D program. Applied in UV mapping mode to the terrain and set to repeat four times over the surface (because the center peaks are about a quarter of the size of the whole terrain object). The map produces a fine gray rubble base on our mountain.

4 A second layer of the same texture is then applied as a second bump map, but is set to tile only once. This creates a layer of larger scale rocky/cragginess for the mountain. This can be done within the same material as a new bitmap layer in the bump channel, or in this case as a separate material applied to the object and set to mix with the one below. The color of the second material is set to black so that only the bumps are added.

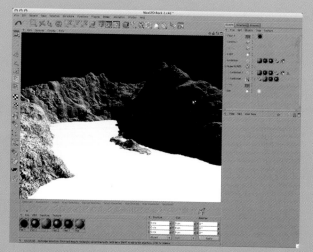

5 A third texture image of mud cracks is applied as a bump map to create another level of detail in the texture. It is set to tile at a high frequency to create the appearance of cracks and fissures in the rock, while a procedural noise texture is used as a mask to vary its intensity and to prevent the cracks from appearing uniformly over the mountain. The mountain is looking okay, but it's still far too smooth. Bump maps can only do so much; we really need to modify the geometry to create larger surface details.

6 Subpolygon displacement (SPD) is a great solution, and using a procedural fractal noise to create subpolygon displacements works wonders as you can see here. However, it can take a while to calculate and render, so for subsequent texturing we'll turn off the SPD until the end. See the CD for a quick test animation of the SPD textured mountain, SPD.mov.

Full terrain texturing

7 If your 3D program doesn't have SPD, you can create a similar result by using subdivision surfaces and normal displacement mapping. Make the mountain object a subdivision surface, and set the rendering subdivision to a high level to "capture" all the details in the fractal noise but keep the rendering resolution low. It's not quite as efficient as SPD, but it does much the same job.

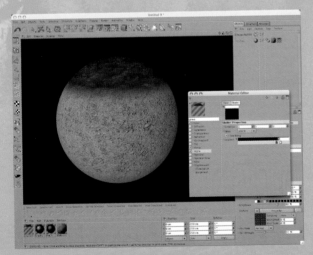

8 Next is the second layer of texture, the foliage, which only appears on parts of the mountain depending on the slope of the rock. Here we have set it up on a test object so it's easier to see what is happening. Where the surface is steeper, there is no foliage; where it is more level, the foliage can take root. This is accomplished using a falloff shader as a mask for the green texture map.

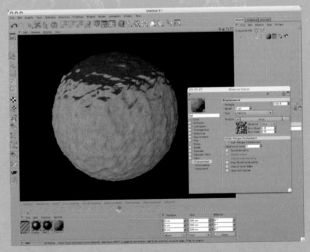

9 The falloff shader analyzes the terrain's surface and calculates the angle between it and the Y (up) direction at each pixel in the image. Where the angle is similar, the surface is less steep, and this is where the foliage appears. Enabling the displacement gives a more realistic result, as the surface now has more detail.

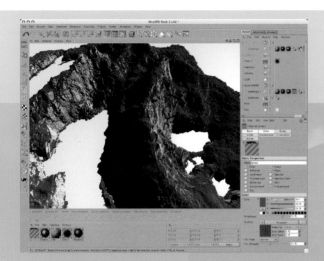

10 The foliage material is also given SPD, but at a lower subdivision to create a less ragged surface, as you'd expect to see. We've also used the trick of changing the shader illumination mode from the default Phong, to Oren-Nayer. This mode simulates matte surfaces better, and this makes the foliage look less plasticky. A fine noise bump map produces the higher-frequency detail in the foliage.

11 The foliage material itself is quite complex. Here's the texture that is used. It was created using the pattern maker filter on an image of a wooded valley. The Pattern Maker generates a random, uniform texture from the photo, which retains some photographic detail but in a form useful as a texture map.

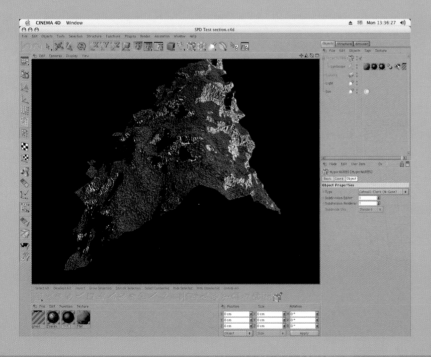

12 When applying and testing the textures, it can be useful to use a much less complex scene so that SPD can be enabled. Here, we have selected a small portion of the landscape and deleted the rest. Now we can render using SPD to get a better idea of how the texture is working.

Full terrain texturing

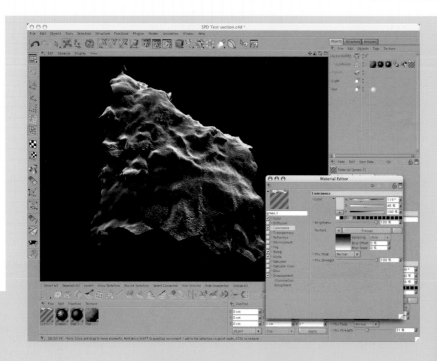

13 Color and bump detail is one part of the equation, but it is also important to simulate the way that materials react to light. A subtle backlight/edge-scattering effect is achieved using a Fresnel shader in the luminosity channel of the foliage material only. Here is it applied without adjustment so that you can see the effect.

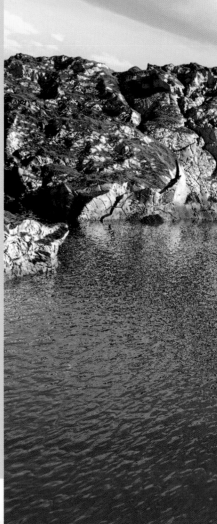

14 Fresnel is a falloff effect that calculates the angle of the surface from the camera's point of view. In this case, the further the surface points away from the camera, the greater the effect of the shader. You can usually adjust the effect using a gradient, as is the case here. The black point (zero effect) is moved inward to reduce the spread of the falloff. The color of the luminosity is changed to a light green as well.

15 Reducing the intensity of the effect produces a much more realistic result. It's very subtle, but it is one of the finer details that adds up to make the texture really work. The effect is similar to velvet, and some 3D programs have such a shader built in that could be used as an alternative.

16 Here's the finished mountain, complete with a reflective water plane and sky. A small amount of ambient light is used to illuminate the shadow areas, and you could use radiosity rendering for even better illumination. See the file NiceSPD Rock.c4d on the CD.

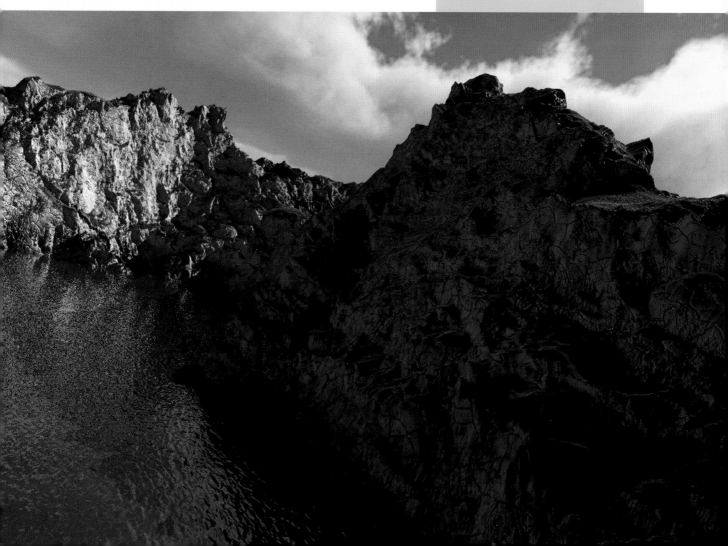

Simple water planes

A body of water can be made simply by adding a large (or infinite) flat plane to the scene. Indeed, this is how most landscape-rendering applications do it. This flat plane is therefore totally dependent on the material that is applied to it to look like water, and there are usually two important aspects to getting a good water material: transparency and reflection.

1 A flat plane with a plain material is added to a scene to make a large body of water such as an ocean. If a ground plane is present, and you want to create deep water, then delete the ground pane.

2 Adding transparency to the plane is the beginning of creating water. However, something needs to be under the water for the effect to work. As you can see, the terrain's edges are visible now, so we need to add another submerged terrain to hide that.

3 With the submerged terrain added, we can continue editing the material. The next thing to add is some reflection. Fresnel falloff is applied to the water, and a reflective index of about 1.5 is used in the transparency section. The clouds and mountain are reflected in the water, but because the plane is totally flat, it doesn't look like water yet.

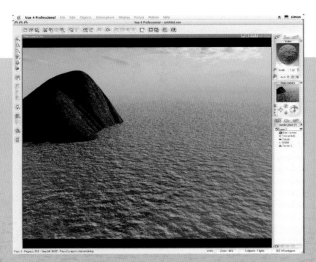

4 Adding bumps to the water using a procedural texture gives that all important realistic wave and rippling quality. Bumps are so important because they affect all of the other properties of the water, the reflection and transparency.

5 The final touch is to add highlights to the water material. Specular highlights in water should usually be very strong and tight, but you may find that increasing the width of the highlight gives more of the glinting effect that makes a good ocean look right.

6 Because this water material has so much reflection, highlights, and transparency, the look of the water will vary greatly depending on the viewing angle and the position of the sun. With the sun low on the horizon, the specular highlights and reflection are accentuated.

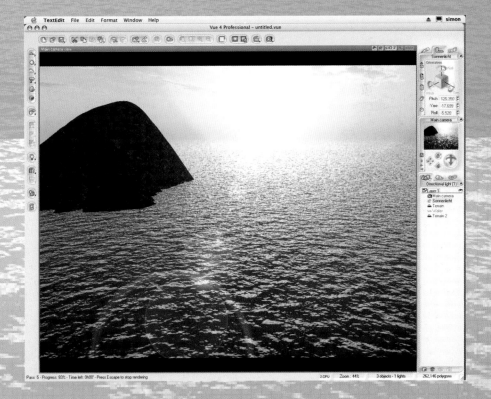

Complex water planes

Simple water planes are fine for distant shots where there is little variation in wave amplitude. For any kind of water where the surface is not flat, though, a bump map will not be sufficient to convey the impression of waves. Once again, either displacement mapping or modeling of the waves in some other way will be necessary.

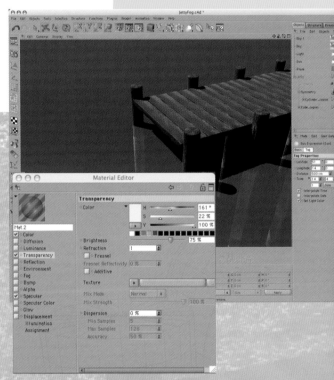

1 In this example, the scale of the image field of view is smaller, as if it is being viewed at roughly the height and distance of a person standing nearby. A plane is added to the scene for the water surface and scaled so that its edges are not visible. This is fine for a still image such as this, but in an animation where the camera angle changes, you risk seeing the water plane's edges. Either use a much larger plane or a technique like that outlined on page 26 "Camera-Optimized Terrain."

Any time the horizon is visible, then things get tricky when using finite objects. However, waves can be a savior in this regard, as we'll see in the following pages. The 3D model for this example can be found on the CD as jetty.c4d.

2 As we all know, water is usually transparent, but simply enabling transparency for the plane's material does not give us the look we're after. For a start, you can see the whole of the length of the legs of the jetty. Taking into account that this water is in a grimy dock somewhere, it's not going to be 100% transparent. But this doesn't mean that reducing the transparency is the solution either. The transparency needs to be attenuated according to the depth of the water, and it must not be done uniformly.

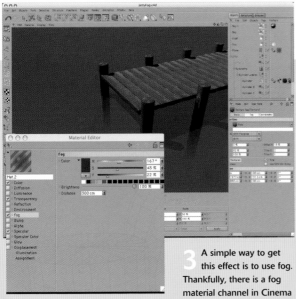

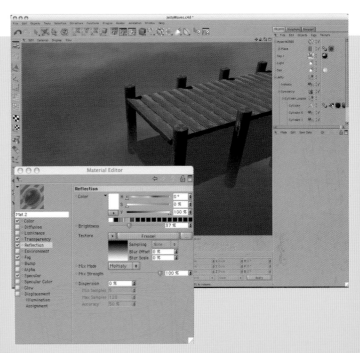

3 A simple way to get this effect is to use fog. Thankfully, there is a fog material channel in Cinema 4D. All that's needed is for this to be enabled for the water plane texture, the color of the fog set to a murky dark green, and the fog distance set to the correct value. This value is dependent on scene scale; here it's reduced from the default 1000 to about 350. This gives us precisely the effect that's required; notice the way that the jetty poles now disappear into the murk. This can be found on the CD as JettyFog.c4d.

4 Reflection is applied to the water plane using Fresnel falloff to attenuate the reflection strength depending on the angle between the water surface and the view. A sky object with a basic texture supplies the necessary reflection environment.

5 Note that the legs of the jetty appear stunted in the previous image. This is just the reflection of the legs in the water—the fog effect has only been spoiled temporarily. To create some waves in the water, a deformer is added to the plane object.

This particular deformer uses a function to generate radial waves. Converting the plane to a subdivision surface makes sure that the water surface remains smooth despite the deformation.

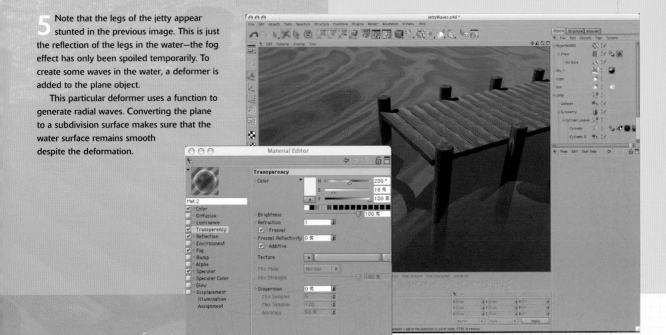

Complex water planes

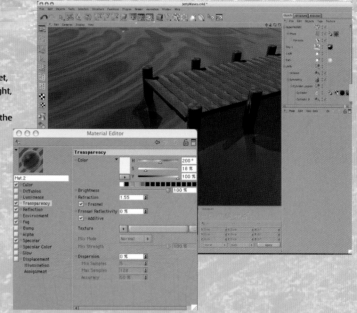

6 The deformation disrupts the reflections so that the fog effect is once again visible. There is no refraction enabled yet, though, so the jetty legs viewed through the water appear straight, but this would not be the case in reality. Setting the refraction index to 1.55 and rendering with ray tracing enabled generates the proper refraction effect.

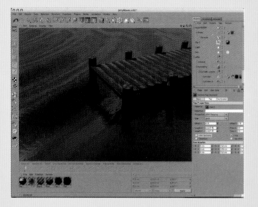

7 The deformation gives the large-scale waves, but water has many levels of waves and wavelets, and bump mapping will be the best way to generate these smaller waves. Fractal noise again does a good job of simulating small surface undulations.

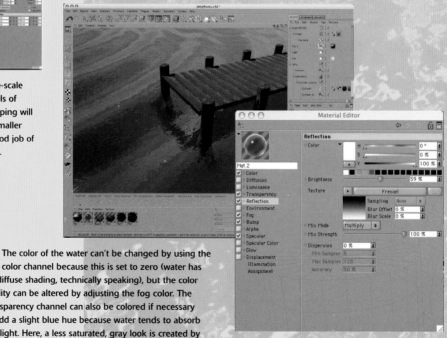

8 The color of the water can't be changed by using the color channel because this is set to zero (water has no diffuse shading, technically speaking), but the color quality can be altered by adjusting the fog color. The transparency channel can also be colored if necessary to add a slight blue hue because water tends to absorb red light. Here, a less saturated, gray look is created by reducing the color of the fog.

9 The specular highlight of water is an important factor in making it look realistic. In this example, we've lowered the sunlight so that there's a more obvious specularity on the water. It's way too broad, though.

10 A narrower specular highlight creates a more detailed water surface, but it's highly dependent on the bump map used. Adding a very faint, fine noise pattern to the bump channel gives this shimmery effect.

11 For the most accurate highlights, turn off specular reflections and instead use an HDRI (High Dynamic Range Image) reflection map as a material environment, adjusting the brightness so that only the brightest pixels in the map are reflective.

Simulating wetness

Water doesn't just lie conveniently in large bodies like lakes and seas; it soaks into things and pools on surfaces making them wet. Transforming a dry surface into a wet one can be a tricky task, and it depends a lot on the nature of the surface that you are trying to simulate. In this example, we have a road cutting through a stretch of flat, barren landscape. A dry, matt surface such as tarmac will react to a drenching in a different way than the powdery soil that surrounds it, but both can be made to look wet by making careful adjustments to their materials.

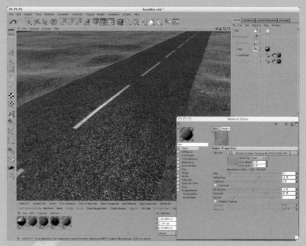

2 When the dry earth gets wet, it gets darker and richer in color. Here, the bitmap that we've used for the earth's color texture is edited to give it more contrast and a little more saturation. You could do this in Photoshop, but in this case a filter shader with similar controls is used directly in the 3D program.

1 Here's the test scene, a road over a dry, dusty landscape. When the rain comes, the two surfaces will look quite different from how they do now. Note that the road is very matt with only slight specular highlights that have been created by using a high-contrast version of the tarmac texture. This can be found on the CD as Road.c4d.

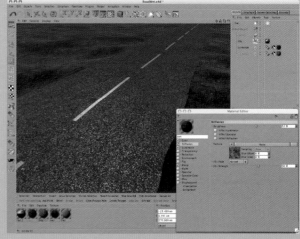

3 To darken the soil you can either reduce the intensity of the color texture, or if you have a separate Diffusion channel, you can use this to darken the surface. In addition, we've attached a noise shader to provide a little variation.

4 The road is a little trickier because the water will not soak into its surface as much and will tend to pool and well in the pits in the tarmac. A number of things happen when water soaks into a surface like this. The first is that it gets darker like the earth. To do this, again we reduce the Diffusion channel's intensity, to make the road very dark.

5 However, the white line markings have also disappeared, and these need to be brought back. A simple solution is to create a new texture that is made up of just the lines on a back background. This can be applied in the Diffusion channel (or in the Luminance channel) to prevent the lines from being darkened.

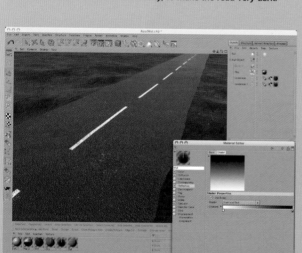

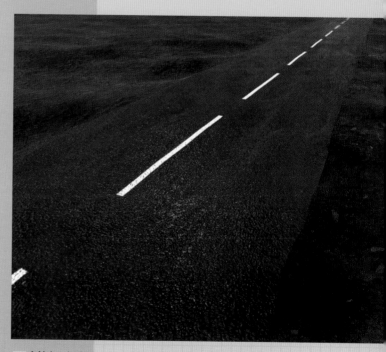

6 Water is reflective, and, depending on how absorbent they are, so are wet surfaces as a result. The road will tend to hold the water until it evaporates or soaks in, so we have to enable reflection for the surface. Fresnel falloff is used to vary the reflection, depending on the viewing angle. A sky object with a texture has been added into the scene to give the road something to reflect.

7 A Noise shader can be layered with the Fresnel shader to add some variation to the reflection. Here, the bump texture has also been blurred slightly to give a less etched look to the road bumps and to create a smoother reflection pattern. See RoadWet.c4d on the CD.

Animating ocean waves

If you want to create an open body of water, such as an ocean, you can do so using a technique similar to the camera-optimized terrain outlined in Chapter 2. This system utilizes a simple camera rig to link the motion of the camera and the water surface object so that they move together when the camera pans or translates horizontally, but it remains stationary when the camera banks or tilts, or moves vertically. Utilizing world space coordinates for the textures applied to the water plane results in a virtually infinite ocean that looks good no matter where the camera is pointing.

1 The initial step is to create a subdivision surface "cone" object whose resolution can be altered freely. This object is a plane that has more divisions closer to the narrow end, where the camera will be located. The plane is very large, a number of miles in size, so that it is effectively infinite when viewed through the scene camera.

2 This object is then imported into LightWave Layout for displacement mapping in order to create the waves. You can do this in any 3D program that has displacement mapping and world coordinates.

The rig is set up with the camera and wave plane parented to a Null object named Rotator. It is set to rotate only in Heading (pan). The Rotator is parented to another Null object named Mover, which is set to not rotate at all, and only move on the Z- and X-axes (not the Y-axis, up and down). The camera can only be moved up and down and cannot pan (rotate in heading). This allows full movement and rotation by keying the camera and two Null objects in their free axes only.

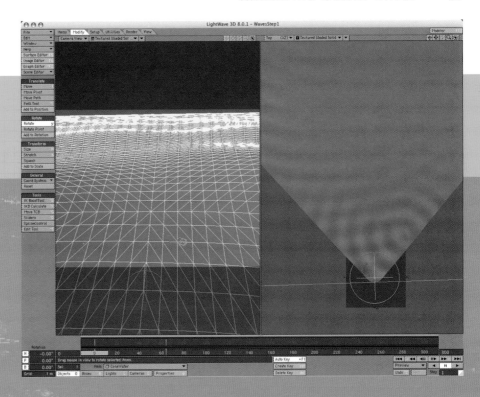

3 For the waves, a displacement map can be added to the water plane. Using a shader that produces concentric rings, and a very long wavelength (a value of 50 in the shader's units), creates a slow rolling wave displacement. This forms the base movement of the waves on top of which can be added a sequence of shorter wavelength displacements.

4 A midrange wavelength (value of 33 in the shader's units) is added in a new layer above the previous shader and set to Additive mode so that both displacements are combined. Its speed and position are changed so that the two waves interfere and give a more realistic motion. See the Waves1.mov file on the CD for an example.

Animating ocean waves

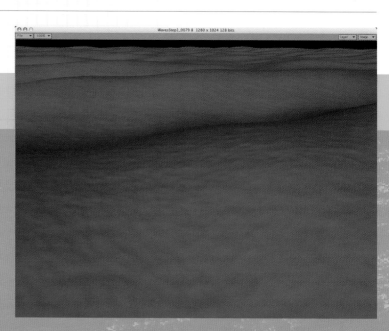

5 Depending on the scale of the scene (either far away from the water surface or close to it), you can change the speed of the wave motion. For a large-scale scene, the waves would be bigger and therefore move more slowly. A third high-frequency displacement is added in the form of a fractal noise shader (called Crumple) to provide some smaller wave details. A quick render shows these bumps better.

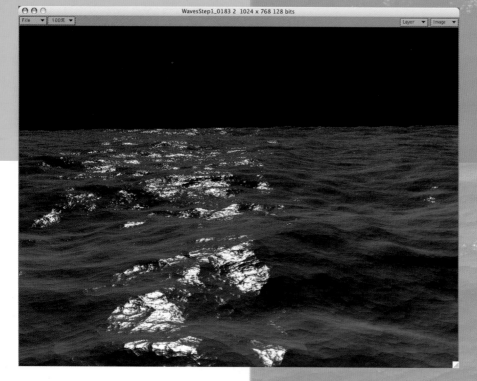

6 It is pointless to use displacements for any smaller waves, so at this point bump mapping takes over. Here a stack of two more Crumple shaders in the wave object material's Bump channel provide the finer wave details.

Again these are all applied in world coordinate space to allow the textures to move independently of the wave object. Specularity is then enabled to show the bumps more clearly.

7 The Crumple shaders don't themselves have animation parameters like the Wave shaders, but they can easily be animated by keyframing their motion in the Y-axis (up and down). This moves the fractal pattern through the water plane, but perpendicular to it. Here is one of the function curves that animates the texture; it is just a simple linear curve between the two values. Run the movie test4.mov on the CD to see it in action.

8 Now you can animate the camera to fly over the ocean any way you like. To do this, though, you need to split the motion between the various Null objects and the camera—if you make a wrong move, the illusion of an infinite ocean will be spoiled. Here we have keyframed the camera and Nulls (Mover and Rotator) so the camera appears to pan down as it flies over the water's surface. See test5.mov on the CD.

Texturing an animated ocean

Once you've animated the base geometry of an ocean plane, you will need to texture it. This is actually a little more complicated than at first it might seem. Although in reality water has a defined surface property (well, a volume really), it doesn't usually makes sense to model all the properties accurately in 3D. It's far better to create different kinds of water surfaces depending on the situation. For example, you probably wouldn't use the same surface settings for an ocean as for a glass of water. Why would this be so? Well, even though water is transparent, under certain conditions its transparency becomes irrelevant, such as when looking at a large expanse of deep ocean. In such a scene, there is nothing below the surface to see except more water, so in effect the water becomes, for all intents and purposes, opaque. This is good for the 3D artist because rendering transparency with the necessary ray traced refraction is very computationally expensive. If you do happen to have objects below the surface, then rendering with transparency will be mandatory, but again there are ways to optimize the surface for this, too.

1 In a slightly stormy ocean, as the surface of the water rolls and churns, the wave crests can become lighter due to tiny air bubbles forming in the turbulence. This can be simulated using a simple black-to-white planar-mapped gradient applied through the water on the Z- or X-axis.

Here, we've created the gradient in Photoshop. Note that the image size is at least 512 pixels high, and the gradient is reflected along the horizon. This allows for the full range of brightness values (256 for an 8-bit image) and will help to create a seamlessly tiling texture.

2 As the wave crests rise, they become whiter due to the gradient, while the troughs are black. Applying this gradient in the Color channel provides the lightening effect that we desire. Scaling and moving the texture in the Y-axis allows the texture to be positioned to get the best result.

3 The intensity of the gradient is reduced to about 30% because the effect is not meant to be too obvious, just a subtle lightening. The actual color of the surface will be set to a dark green so that the crests, when textured, take on this color. The unchurned water itself has no color.

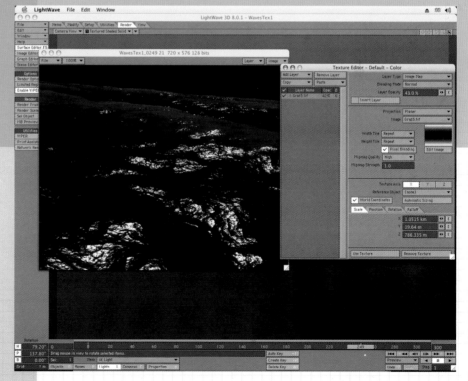

Texturing an animated ocean

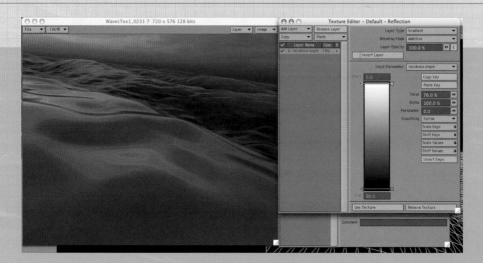

4 Most of the surface color of an ocean actually comes from the reflection of the sky, so a large, inverted-normals skydome sphere is added and textured with the sky image. Enabling reflection (with Fresnel falloff supplied using a gradient in LightWave set to Incidence Angle mode) provides the sea with the necessary color.

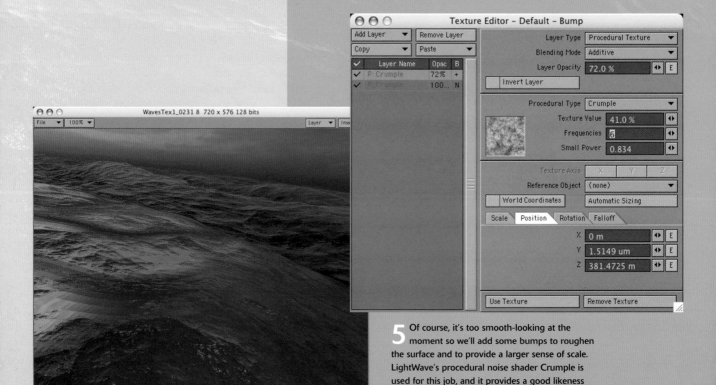

5 Of course, it's too smooth-looking at the moment so we'll add some bumps to roughen the surface and to provide a larger sense of scale. LightWave's procedural noise shader Crumple is used for this job, and it provides a good likeness of smaller wavelets for the water surface.

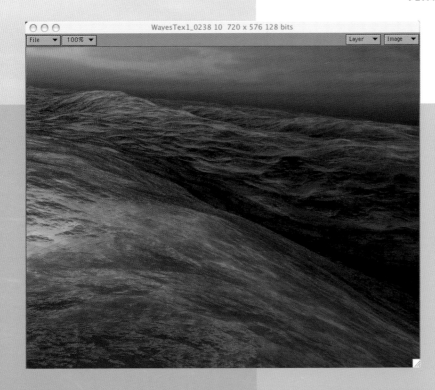

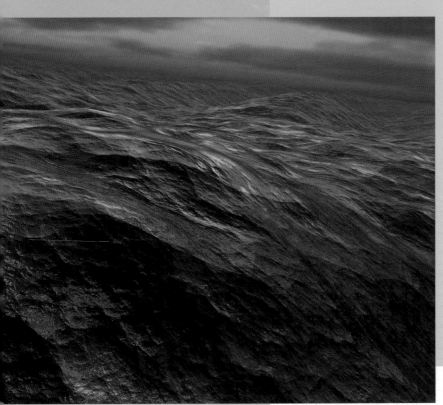

6 Another gradient is used to create the wave crests' foam and froth as the small wavelets break on the water's surface. This is applied in the Color channel in Additive mode (to boost the color of the surface); it's an interesting use of LightWave's gradients that can save a lot of time and effort.

The gradient is set to Bump mode, so that the colors that are set in the gradient are applied based on the bump height. Where the bumps are highest (at the wavelets' crests), white is applied, so that we get the desired foaminess in the right places.

7 Specular highlights are added as usual to create the sparkling reflections. Although they are best created using HDRI images, this "fake" method works in this example. The color of the main light has been changed to orange to better match the background image. The end result can then be rendered out as a movie, a version of which you can see on the CD as OceanFullBig.mov.

Simple sky

Creating skies is relatively easy if you just want a simple effect. All landscape-rendering programs offer a built-in sky-rendering system to generate moderately detailed skies pretty much automatically. You can simply use the presets and get good results, but editing them can offer you more control over the final look. This is especially important when it comes to the mood of a landscape image because the sky has much to do with the overall feel.

1 The default sky settings in Bryce, for example, offer a simple sky with a sun/moon, clouds, haze, and fog if necessary. The first parameter you might want to change is the skydome color. Here's the default blue, which is a little over the top.

2 Selecting a less saturated blue for the main body of sky and a pale blur for the horizon color creates a gentler, less CGI-looking sky. It also has the side effect of making the clouds look better, too.

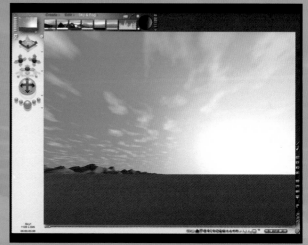

3 Panning around to look at the sun, we see that it's a little too bright, and the glow is too intense. This is the main problem with many default settings in these kinds of programs; the settings are often too high.

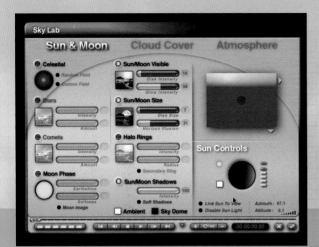

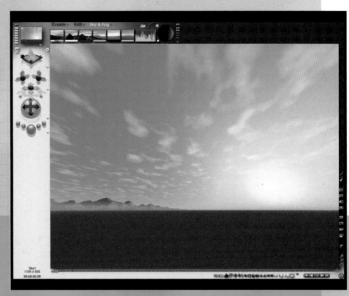

4 Bryce has a sky editor, called the Sky Lab, where you can make adjustments to the atmospheric settings. Reducing the halo strength and disc size help to alleviate the problem of the overly glaring sun.

5 The sun's color is also adjusted to make it slightly less yellow. A little bit of distant haze is added as well to help integrate the sky with the rest of the landscape scene.

6 The clouds are next for adjustment. There's really no right or wrong way to adjust the clouds in such a program because they'll never look like proper volumetric clouds. However, for a simple sky like this, you can edit the cloud plane to help adjust the mood of the image.

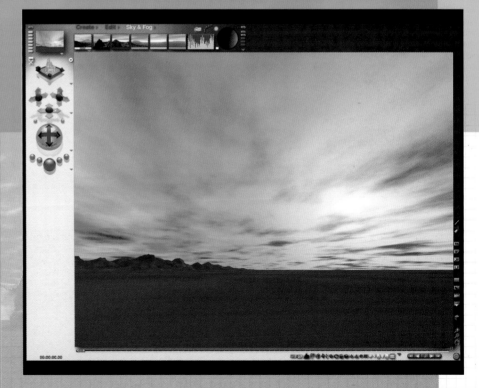

Creating complex skies manually

Using an automatic system to generate skies is great, especially if you're in a hurry, but they can suffer from being too generic and often have a look that is instantly recognizable. If you want to have total control over the look of a sky, then the best thing to do is to build it yourself from scratch. The technique involved is quite simple and should be achievable in any 3D program that has fractal noise shaders.

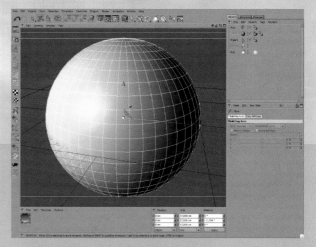

2 A skydome is added to the scene. If your 3D program has a dedicated sky object then you can use that, although we'll use a regular sphere in this example because it's more universal. The sphere is scaled up very large to encompass the scene, approximately 5000 units. If necessary you will need to invert the polygon normals so that the inside of the sphere will be visible when rendered.

1 The base scene has a floor plane and a foreground object to give some scale. A distant light is used to simulate the sun. In this case, it's a special procedural light that simulates the change of color of the sun depending on its location in the sky. You can, of course, just set the color for the sun manually. Hard (ray traced) shadows are enabled for the light.

3 A Gradient shader (sometimes called a Ramp in some applications) is applied in the Luminance channel of a new material (this may also be called Ambience or Incandescence). The gradient is designed to mimic a sunrise/sunset with a reddish-yellow band near the bottom changing through light blue to a dark, desaturated blue at the top. This is applied as a Spherical projection to the sphere.

You may also need to increase the tiling of the material along the Y-axis to compress the gradient toward the top half of the sphere that's visible in the scene.

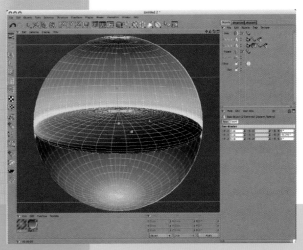

4 A second light is added to the scene at the same location as the sun. Its illumination is disabled, but its visible/glow property is enabled. This provides the glowing halo around the sun. You can also simulate this effect with a lens flare. The glow is set to a yellow-orange.

5 A second sphere is added, the same size as the sky but scaled in the Y-direction (or Z-direction if your 3D program uses a Z-up orientation) to act as the cloud plane. It's a sphere rather than a plane because the sky and ground are both large but finite. If a plane was used, it would intersect the distant sky above the horizon, resulting in a hard line there.

6 A fractal noise shader is applied in the material's Alpha channel to create the cloud texture, and the luminosity is increased to make them self-luminous. You can also apply this in the Transparency channel if your 3D program does not have a separate masking channel. Don't use clipping or genlocking though as that will result in hard edges to the clouds. The fractal is scaled up very large to create the desired low-frequency clouds.

Creating complex skies manually

7 They don't look too great yet, so the first thing to do is to fix the horizon. A Gradient shader is used as another layer in the Alpha channel of the material to mask the clouds out near the horizon. Then a fractal noise shader is applied in the Luminance channel to give some structure to the flat parts of the clouds.

8 Even though the clouds look okay as they are, they still look very flat. The trick will be to give these flat clouds the appearance of volume. First, we have to make sure that all the fractal noise patterns used in all of the channels are set to World Coordinates mode. Next, the cloud object is duplicated 12 to 15 times, and scaled up 101% each time.

9 The objects are scaling up, but the world space fractal patterns remain the same. Because the fractals are calculated in 3D, you end up with a series of slices through the fractal volume. The more duplicates and the smaller the scale increment used, the better the results will be because you get finer slices through the fractal noise. Here's the same texture applied to only four sphere "slices"; you can just about see the gaps between them.

10 You can adjust most of the material properties, such as color and luminosity, to get different looks. Enabling transparency helps to blend the clouds slices and results in a puffier, softer look to the edges. You can also tint the Luminance channel to get pinkish clouds, though you won't get much true volumetric shading because it's only a volumetric fake. Where the clouds pass in front of the lighter horizon, you can make them darker by using an inverted Fresnel shader in the Diffusion channel. This is another benefit of using a sphere instead of a plane for the sky. See Sky2.c4d on the CD.

Realistic sky gradients

One of the surprisingly difficult things to get right when creating a sky background is the gradient that defines the colors in the skydome. You can use a Ramp shader and specify the colors directly in your 3D program. This approach is fine, but it can be a lot easier to make a texture in Photoshop, for a number of reasons. First, if you are creating a sky where the sun is quite low (i.e., near dawn or dusk), then there are a number of colors present in the sky, and getting these to blend without looking fake can be tricky. The other thing is that the colors are not evenly wrapped around the sky; there are more reds and yellows near to the sun compared to the opposite side of the sky.

1 Specifying a gradient or ramp directly in a shader can be fine, but if you're after realism, you might find that the way the colors blend can result in a good but fake-looking sky background.

2 Even adding some noise to the shader to help disrupt the regularity of the gradient doesn't work that well and can make things worse. Part of the problem is that it's quite hard to imagine the right colors in sequence in the sky and be able to add them all straight into the gradient color picker.

3 There are a few simple solutions to this problem, the easiest of which is to create the sky background in Photoshop using photographs as references. Here we've found a sky image, and we are using it to take samples from using Photoshop's Eyedropper tool.

The result is not perfect, but it acts as a good starting point. Notice, for example, how unsaturated the blues are in the image. In fact, they are more lilac than blue.

4 To create the variation in the skydome, a second gradient is created on another layer using another image as a reference.

5 A circular gradient layer mask is used to blend between the two layers, providing a constantly variable range of skies that can be altered simply by changing the layer mask and layer opacity. A weak sunset . . .

6 . . . and a strong one can be created from the same document just by altering these settings. The desired image can be saved out as a new file, and the layered file can be saved for further sky backgrounds when you need them. See the image files Skygrad.psd and Skygrad.tif on the CD.

Animating a bitmap skydome

Although a bitmap skydome texture is by definition static, it's actually quite a simple job to animate a sky that has been textured with one to create a time-lapse sunset (or a realtime sunset if you're creating a very long animation). There's no need to resort to a fancy motion graphics program to create an animated texture movie for the sunset sequence; all you really need is Photoshop and your 3D program.

1 To create this effect, you need to have a series of still images that represent keyframes of the sky's appearance throughout the animation. These images will be blended to create the animated sequence. As such, you really need only a few of them—four in this case. The first image can be created from the same gradient document used in the previous example. This sky is brightened using a levels adjustment layer, and the "glowing" layer is increased in opacity so that there is more orange in the sky. This image is saved as SunSet1.tiff on the CD.

2 The second sky is the same as the one we created in the previous example; it's SunSet2.tiff on the CD. The third one has the glowing sky layer increased in opacity, but the overall sky is darkened using a levels adjustment layer. To compensate for this, a Hue/Saturation layer is used to reduce the overall saturation, particularly in the blues. This is SunSet3.tiff on the CD.

3 The final sky has the glowing sky layer reduced in opacity, and again Levels and Hue/Saturation are pressed into service to darken and desaturate the colors. This is saved as SunSet4.tiff on the CD.

4 All that's needed now is to create a morphing animation that blends between the four sky images over the desired number of frames. There are many different ways to do this—the foolproof way being to create four skydome spheres, each with its own sky material, and then animate the transparency of each. Here, in Cinema 4D, a less fussy way is to load all four sunset images into a single material using the Layers shader, and then to keyframe the shader.

5 The first keyframe has the SunSet1 layer at 100% and all the others at 0%, the second has SunSet2 at 100% with all the others at 0%, and so on. Keyframes are saved for the Layers shader at frames 0, 30, 60, and 90, and the animation is then rendered out. A Sun object is also animated to provide the illumination and glow of the sun itself. See SunSet.mov and Sunset.c4d on the CD for the finished piece.

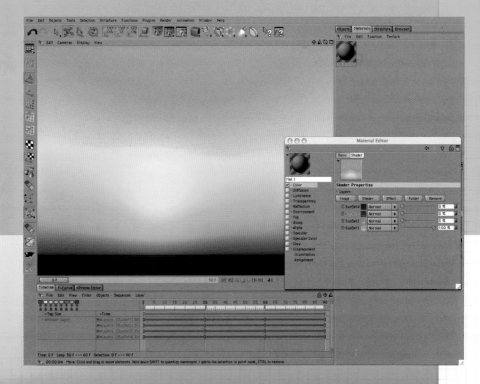

Haze, fog, and mist

Another important aspect of skies and atmosphere is the amount and kind of water vapor it contains. The reason that the sky is blue is due (mostly) to the scattering of certain frequencies of light by the atmosphere. Because blue light is most affected by the scattering, this light is diffused throughout the atmosphere, hence its blue color. Water molecules in the air at lower altitudes can form an obscuring haze that hugs the ground and also attenuates and scatters light, making distant objects seem lower in contrast and tinted slightly blue. When the water molecules form a very rarefied layer, you tend to notice it only at large distance. This is what's known as haze. Conversely, fog is much thicker and therefore much more apparent over shorter distances. Because of the shorter distances, light doesn't travel far enough for scattering to be noticeable; therefore, fog tends to be whiter than haze. Mist is pretty much the same as fog; it's just a lighter version. Haze and fog can have a very large impact on the look of your atmosphere and your scene in general.

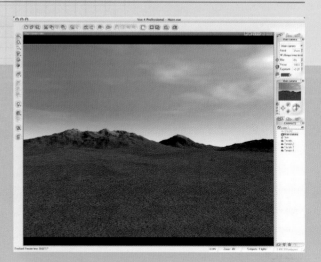

1 A scene without atmospheric haze or fog doesn't look very realistic, especially if very distant objects, such as mountains, are visible. Even on a very clear day, there will be some degree of haze in the atmosphere obscuring the light from distant objects. Without the haze, it can be difficult to judge the distance and scale of the objects in the scene.

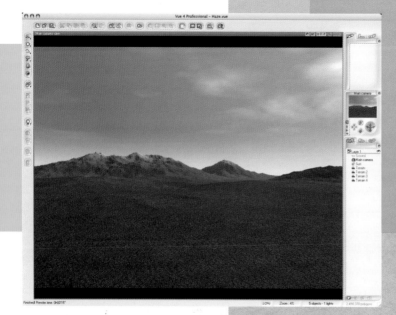

2 Adding just a little haze helps fill in the missing detail in the scene and provides the visual cues that allow us to interpret the scene's scale correctly. Here in Vue, the haze is added to the scene in the Atmospheric editing panel. This file can be found on the CD as Haze.vue.

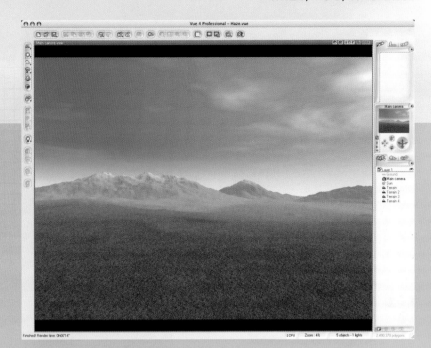

3 Thick haze exaggerates the depth of the scene and causes the distant mountains to wash out into a pale blue band near the horizon. Notice that in this nonvolumetric sky model the haze does not affect the sky background itself.

4 Fog can have the same effect, but it tends to behave differently than haze. Because it is more dense, it tends to pool closer to the ground and fall off quickly as altitude increases. Fog can help to show the shape of the landscape such as the low, undulating ground plane here.

Volumetric haze

Volumetric haze is quite different from standard haze effects that simply affect the color of distant objects. Volumetric haze is a factor of the atmosphere itself, and those programs that allow you to edit the atmospheric haze offer a much more realistic and powerful way of designing the look of your sky. Volumetric haze has the disadvantage of being a much more complex set of parameters to master because of the interactivity with the rest of the variables that make up the sky. It can also be much more computationally expensive to render than simple "post-render" fog and haze effects.

1 In contrast to the simple haze, reducing the haze to zero in a volumetric sky creates a very different result. Volumetric haze simulates the diffusing properties of the atmosphere. Reducing this to zero produces a dark, almost black, skydome that does not diffuse light at all.

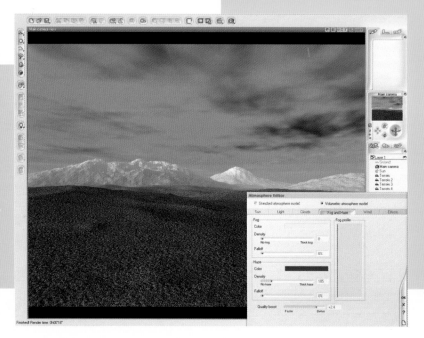

2 Increasing the value of the haze parameter adds back the expected scattering property of the atmosphere. Note that the volumetric haze effect is also more depth dependent than that of simple haze and produces a more extreme effect on the very distant objects.

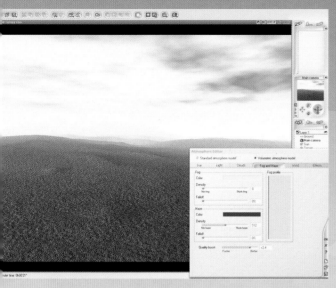

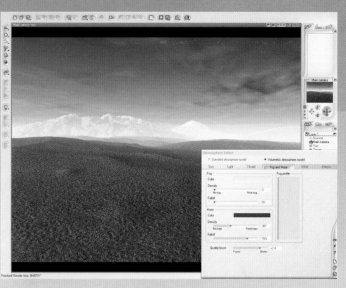

3 Extreme settings result in very bright and hazy skies. Notice that in both low and high haze conditions, the upper sky is affected, too. This is because the haze setting also has a falloff parameter that has been set to zero. Effectively, the haze has been applied uniformly with respect to altitude.

4 When falloff is enabled, the haze quickly thins out the higher the altitude, which better simulates the real effect of atmospheric haze.

5 Because volumetric haze is calculated as a true lighting model, the haze generated is calculated with the correct color when the sun's position is changed. When the sun is near the horizon, the scattering effect comes into play and results in a deep orange sunset. This file is on the CD as VolHaze.vue.

Procedural planet clouds

When creating an atmosphere viewed from above rather then from within, as in the case of a space scene, you will often have to take a different approach to the problem of creating an atmosphere. Clouds become a layer of semitransparent detail floating above the planet's surface, but they can be recreated quite simply by using procedural textures.

1 In Bryce, you can create a space scene by selecting one of the preset skies that has no atmospheric properties, since the atmosphere will need to be recreated on an object rather than in the scene space. You will also have to delete any infinite planes, such as the default ground plane, that are present.

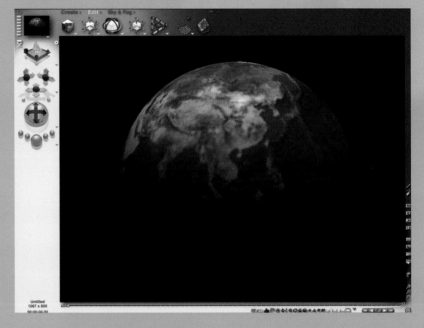

2 The subject for the cloud treatment is our own Earth, and this is created using a simple sphere with a globe texture map applied to it in spherical projection. Without clouds, it doesn't look very Earth-like, though it's fine if you wanted to just recreate a globe.

3 A new material is created based on a basic plain gray material, and a shader is created for the Transparency channel. The texture is a basic fractal noise called Gray Stone, and it's applied in world space. The diffuse color is increased to almost full white, and then this texture is accepted.

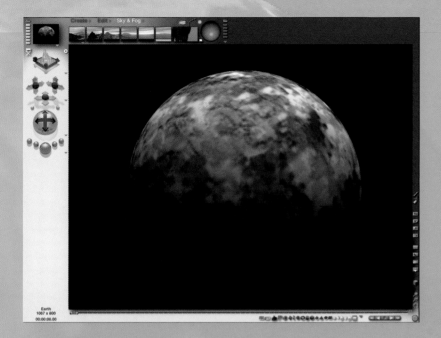

4 When rendered, the cloud layer sphere is partially transparent where the procedural texture is black, resulting in a basic cloud layer for the planet. Because ray tracing is used for rendering, you even get shadows cast on the planet's surface. Though not terribly detailed, it's a simple way to create planet atmospheres in a hurry in a program such as Bryce.

5 Enabling the same texture for the Bump channel and setting a low bump value provides the material with a little surface relief that makes the clouds look a little "fluffier."

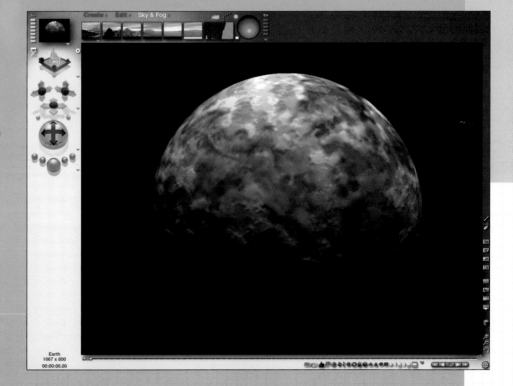

True volumetric clouds

As we've seen, it's possible to fake volumetric clouds using a series of stacked cloud layers and a fractal noise texture in world space coordinates to create slices through the fractal volume. You can, in some 3D programs though by no means all, create true volumetric clouds. Most high-end 3D programs such as Maya Unlimited, Softimage XSI/MentalRay, and Houdini, have this feature, but some of the midrange programs such as LightWave also come with a volumetric rendering facility. With a volume render, the texture is computed in 3D space, rather than on a surface as texture maps and shaders normally are. Though you can have 3D texture shaders, such as the fractal noise pattern used earlier in the book, they are not rendered as volumes. With a volumetric system, you can create clouds, fire, and puffs of smoke as wholly formed objects, and this is where their realism is a great bonus.

1 In LightWave, there is a plugin called SkyTracer that can simulate entire atmospheres complete with true volumetric clouds. It's a good system for explaining how volumetric rendering works. Here, for example, is a skyscape rendered with SkyTracer but without volumetric clouds. The clouds are flat and look like they would in a low-end program such as Bryce.

2 The same settings are used in this render, except that the Volumetric Clouds option has been enabled. We have deliberately set the height of the cloud layer to a small value so that you can see that the volumetric clouds have the same fractal pattern with just a bit more thickness. As a result, light does not penetrate them as much, so they are not bleached out like the previous render.

3 Increasing the height setting makes the cloud layer thicker, but it also increases the rendering times because there is more volume to render. You can see, though, that the clouds are taking on a definite shape and don't look like simple flat streaks of white.

4 Because of their volumetric nature, you can alter certain settings to provide different looks for your weather. Increasing the contrast and reducing the ambient light setting for the clouds produces heavier, darker clouds giving the impression of a coming storm.

True volumetric clouds

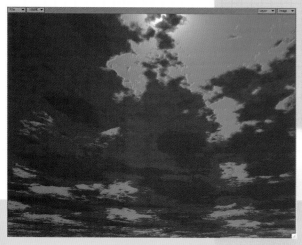

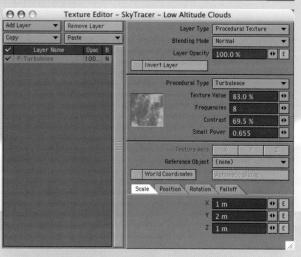

5 Increasing the density setting of the volume affects the fluffiness of the cloud edges. Higher density settings produce a thicker cloud volume with harder, more etched cloud edges. This is useful for creating darker clouds because they tend to be thicker. It has the bonus effect of increasing the rendering speed because the rays do not have to travel through as much of the cloud volume. However, this can result in clouds that look a little unrealistic if the settings are too extreme.

6 In LightWave, as in most volumetric cloud-rendering systems, fractal noise textures are used to generate the cloud patterns. It's the same interface and the same procedural textures that are used for any other kind of surfacing. By altering the properties of the Fractal shader, you have another way to control the clouds.

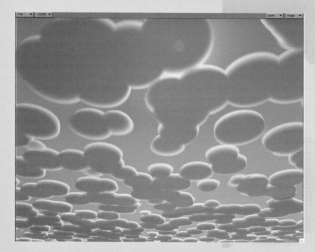

7 By choosing an unrealistic procedural texture, you can create strange, unrealistic clouds, whose volumes still behave realistically. Here, a blotchy shader is used to create marshmallow-like puffs that might be useful for creating a cartoon landscape.

8 Because the volumetric clouds can take a long time to render, the most efficient way to use them is to render out a background frame of just the clouds and sky. LightWave, for example, lets you do just this, and it can render out a SkyTracer sky as a spherical, cubic, planar texture map, or even a Lightprobe image. (The special 360 degree format used for certain kinds of HDRI rendering programs, including LightWave itself.)

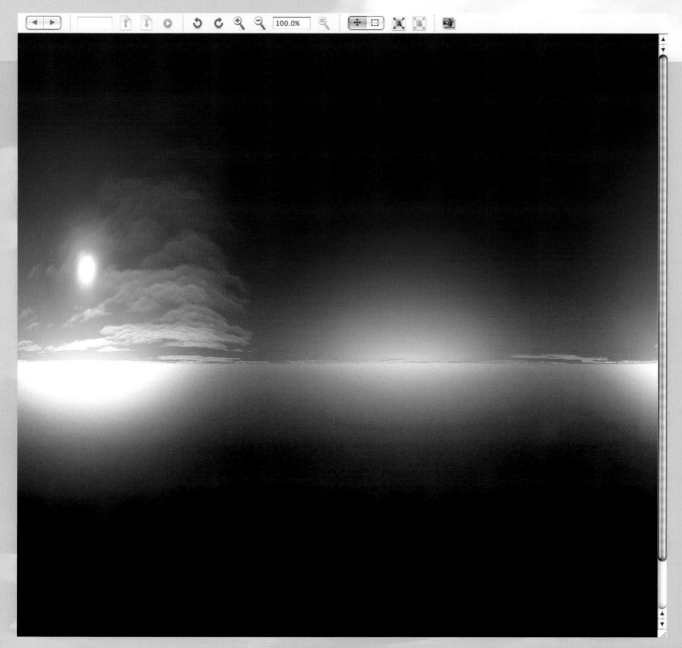

9 Once rendered, the sky can be imported as a normal background image for use in your scene. This has the benefit of much faster rendering when producing animations because the background sky is simply a texture map rather than a volumetric process that's recalculated for every frame. See the spherical Skytracer_2.tiff sky image on the CD.

Realistic planet and atmosphere

Though we've looked at creating worlds from roughly ground level, there's nothing stopping you from increasing the viewpoint altitude even right above the planet's atmosphere and into space. When you look at a whole planet, such as the Earth, with its vast amounts of detail, it may seem an impossible task to recreate it in 3D. However, there are plenty of images of the Earth from space that you can use as references when planning how to tackle such as scene. One of the crucial aspects is getting the atmosphere looking right. The atmosphere includes cloud detail that would be difficult to recreate using procedural shaders. There is considerable structure in Earth's clouds, and they have a very specific appearance. A better approach is to search the Internet for images of the Earth and its clouds that can be used as texture maps.

1 The model for the Earth is nothing more than a simple sphere, seen here modeled in LightWave. However, we'll also need a second sphere to host the cloud texture.

The second sphere can be created in a new layer, or you can simply copy and paste the original. Notice that the sphere has a high subdivision to allow you to zoom up quite close to the edges without seeing facets, though it will also have implication for the volumetric effect later.

2 To be absolutely sure that there is enough resolution, the model is converted to a subdivision surface. The high resolution of the base mesh keep the sphere round. If it was a lower resolution, then the smoothing would cause the sphere to squash too much.

3 The second sphere is scaled up a very small amount, 100.5% to be exact. This makes sure that the clouds float above the Earth and prevents shading errors caused by coincident polygons.

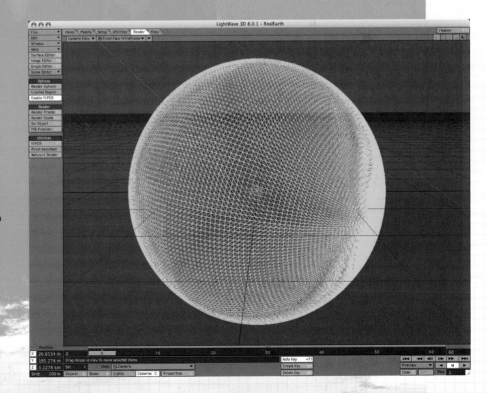

4 The model is saved and loaded into Layout for texturing and rendering. Each of the spheres is assigned a separate surface and named for easy recognition.

Realistic planet and atmosphere

5 Finding suitable texture maps is just a matter of searching the Internet. There are companies that sell very high resolution images of the Earth as spherical projection maps, but if you look hard enough you can find lower resolution versions for free. Using a search engine is a good start.

6 www.oera.net/How2/TextureMaps2.htm is a site that has several high-resolution Earth textures including a cloud layer. You can download and use these images royalty free from the site. The Earth color texture map looks like this. This particular color map has been adjusted to take into account the effects of Earth's atmosphere, which will help a lot in the final image.

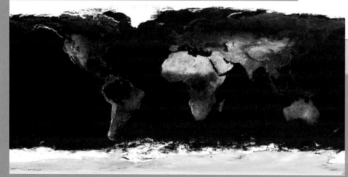

7 In LightWave, the Earth texture map is applied to the Color channel of the Earth sphere's surface properties. It is applied with Spherical mapping, resulting in a perfect globe.

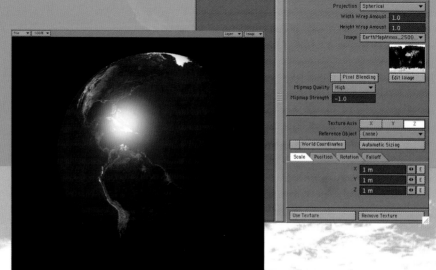

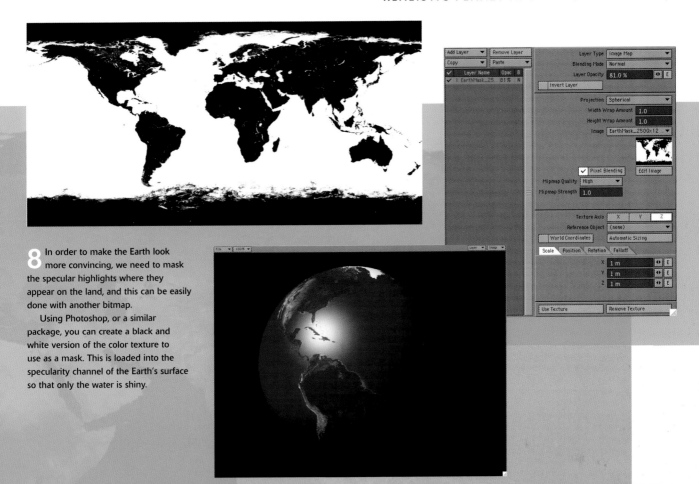

8 In order to make the Earth look more convincing, we need to mask the specular highlights where they appear on the land, and this can be easily done with another bitmap.

Using Photoshop, or a similar package, you can create a black and white version of the color texture to use as a mask. This is loaded into the specularity channel of the Earth's surface so that only the water is shiny.

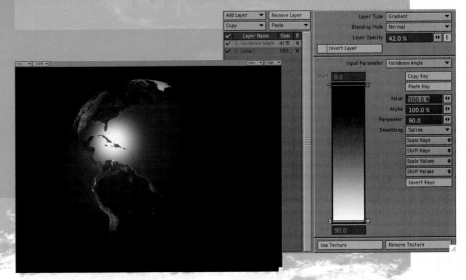

9 The solar phenomenon known as the Limb Effect can be created by adding a Fresnel falloff shader (accomplished in LightWave using a gradient set to Incidence Angle mode) in the Diffuse channel of the surface. This causes the edges of the planet to dim slightly. Although it's a subtle effect, it will help in the final image.

Realistic planet and atmosphere

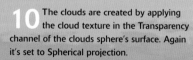

10 The clouds are created by applying the cloud texture in the Transparency channel of the clouds sphere's surface. Again it's set to Spherical projection.

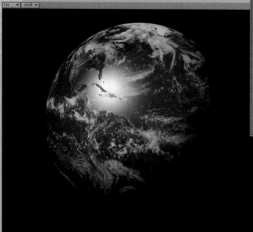

11 You can optionally apply bump mapping to the clouds to give them a little surface relief. This can be achieved using the same cloud texture as in the Transparency channel. The bump level doesn't need to be set very high, just high enough to add a little texture to the cloud surface.

13 The point light's volumetric attributes are enabled, and its size is increased until it's just about visible around the Earth as a faint glow. Because the light is volumetric, all you see is a thin sliver that is outside the Earth's volume.

12 The final effect is to simulate the atmosphere itself. This can be done in a variety of ways, but it is probably easiest to do it with a glowing light. In LightWave, a new point light (Omni) is added to the scene and positioned in the center of the Earth.

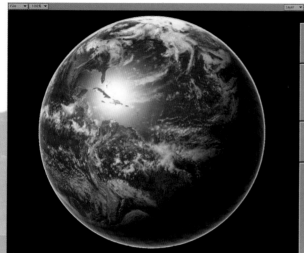

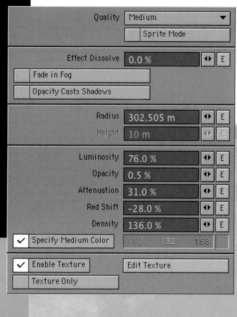

Quality	Medium ▼
Sprite Mode	
Effect Dissolve	0.0 % ◆ E
Fade in Fog	
Opacity Casts Shadows	
Radius	302.505 m ◆ E
Height	10 m ◆ E
Luminosity	76.0 % ◆ E
Opacity	0.5 % ◆ E
Attenuation	31.0 % ◆ E
Red Shift	-28.0 % ◆ E
Density	136.0 % ◆ E
✓ Specify Medium Color	110 132 168
✓ Enable Texture	Edit Texture
Texture Only	

14 This isn't right, of course, because the atmosphere is blue. LightWave has two ways to make a glowing light source blue. You can either set its color to blue using the color picker, or you can use the Red Shift option but set it to a negative number. The best way to get the right look is to simply play with the settings as we have done here. This is because they are very interactive, and changing one tends to affect the other settings. The idea is to get a blue haze on the limb and a faint halo around the planet edge.

15 Ideally, the glow shouldn't be visible on the dark side, and you can fix this by first parenting the glow light to the sunlight and then using the Motion option to make the glow light point at the sun. This has the effect of aligning the glow's Z-axis toward the sun, which can then be used to move the glow a fraction toward the sunlight so that more glow is visible on the illuminated side of the planet.

We've also increased the subdivision level of the spheres to reduce the appearance of facets resulting from the volumetric glow.

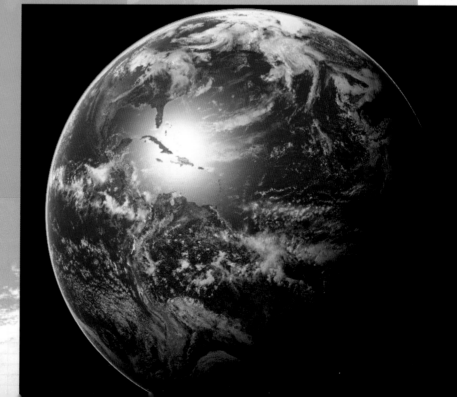

Sun

No sky is complete without at least one sun, and it's actually quite easy to add these objects to your environment. If you're using a dedicated landscape program, then it will be automatic. However, you may still want to customize the look, in which case you can use a glowing light to simulate the halo around a glowing sun, or moon for that matter. If you're using an ordinary 3D program, then using a glowing light, or lens flare, is usually the best way to accomplish celestial objects such as the sun.

2 To get around this, you need to add a second glowing light to the scene, positioned in the sky where the distant light is emanating from. It doesn't have to be 100% accurate, but the more accurate you can get it, the better off you will be. A point light or spotlight is ideal for this job.

1 A sunset without a sun simply fails to look any good at all, no matter how colorful the sky gradient may be. In this scene, a distant light is being used for illumination, but often, as in this case, distant lights can't be set to glow.

3 Glow is enabled for the point light, but its actual illumination property is disabled so that no extra illumination is cast into the scene. A quick render shows the glow. It's good, but not great; it's too bright and too white.

4 By reducing the glow brightness to about 50% and changing the color to a pale yellow/orange, we get a better, more realistic glow that matches the backdrop. Note that glows are usually additive, so the brightness will add to whatever is behind the glow.

5 The glow radius can be changed to make the sun bigger or smaller. This is useful for creating telephoto-style effects where the sun appears very large in the background.

6 Enabling lens flares for the light is the final touch (though in some programs you have to use the lens flare effect to generate the glow anyway) and adds realistic lens reflections from the bright light source. These effects occur inside a camera and are artifacts usually avoided by photographers. See the scene Glow.c4d on the CD.

Rain (or snow)

Rain comes in all kinds of shapes, sizes, and behaviors, so there's no hard and fast rule for how to make good-looking rain effects. Distant rain can look like subtle dark bands over the background, so these might best be created by using texture maps or by painting directly onto a background image. This is fine for a still, but for animations you need to have moving rain drops. Rain near the camera will look more like individual drops, and this is quite easy to create using a particle system.

2 Increasing the particle speed and birth rate creates the desired rain effect. The faster the rain, the heavier it looks. Because the rain drops are only seen a few feet from the camera, they should pass through the image very quickly. Ideally you shouldn't be able to track a single drop over more than two frames.

1 For this effect, it's necessary to use a 3D program that has a particle system, though there are ways to fake it using animated texture maps as well. The first thing to note is that individual rain drops are only visible close to the camera, so you don't need to drop rain over the whole scene. The particle emitter is placed above the camera and scaled up so that rain will fall across the whole width of the image (the camera's green cone in the picture), and to a short depth into the scene.

3 Geometry is used to create the drops themselves. Most 3D applications let you define a single object as a particle replacement object to be used in place of each particle. Here, we are using a simple narrow triangle. A target expression is used on the object to keep it pointed toward the camera at all times. This lets us keep the geometry to a minimum. If you don't have that facility, then making the triangle a tapered prism instead will work well too, though it will triple the polygon count.

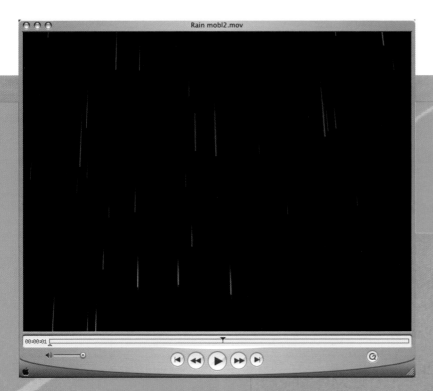

4 The triangle is given a material that is 50% transparent, and then a movie of about 75 frames is rendered out with Motion Blur enabled. This is a frame from the resulting movie. See the files Rain mobl.mov, and Rain.c4d on the CD.

5 This movie can then be overlaid onto your plain environment render in a post-processing program, such as After Effects or Combustion, to add the rain effect. Alternatively, you can apply the movie as a transparency texture in a material applied to a plane placed directly in front of the camera. When adding rain, don't forget to reduce the lightness of the main scene render and desaturate it a little, too. See RainComp.mov on the CD for an example.

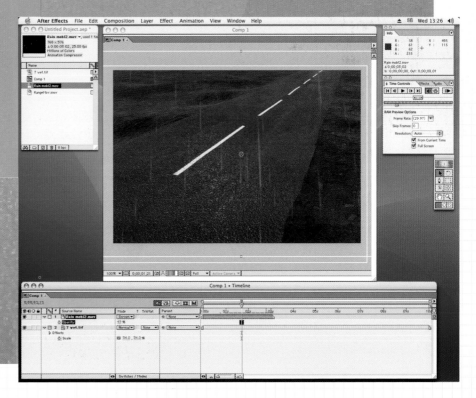

Lightning

Lightning is a natural phenomenon that can be simulated in many ways using 2D or 3D techniques. You could quite easily create lightning in a still image by painting it in Photoshop or some other 2D bitmap-editing application. Another way would be to source an image of lightning from the Internet and, copyright permitting, use this image directly as the lightning bolt in your landscape utilizing the usual compositing techniques.

It would not be difficult to create a lightning bolt by hand in a 3D program using polygons or extrusions along spline curves, though it would be time consuming. Instead, though, we'll use a bit of lateral thinking to create a lightning bolt employing something not usually used for such purposes.

1 A bolt of fork lightning follows rules of fractal branching similar to those of trees, except of course that trees fork upward and lightning bolts tend to fork downward. Because of the similarity, it's pretty easy to use a 3D tree generator as a fractal lightning bolt generator instead. In this case, we'll use a standalone program, Tree Pro by Onyx Software, though the tree and foliage tools built into landscape applications such as Bryce and Vue can also by used.

2 Removing the foliage reveals the beginnings of the branching structure, which is a bit too dense at the moment. By adjusting the controls of the software, the density of the smaller branches can be reduced to make a cleaner fork.

3 If the option is available, you can roughen the branches to make them zigzag in a more electrical-looking way. If this parameter is not available, then you can always use a fractal noise deformer or displacement map on the final geometry to roughen it up. The final fork can be exported as a 3DS file and opened in your main 3D program.

4 Once opened in your 3D program, all that's needed is to change the material to one that is 100% luminous and, of course, to flip the bolt 180 degrees. A quick render shows that the model is looking pretty good.

5 The final thing is to enable a bit of glow for the material. Here, in Cinema 4D, glow is available as a Material channel, but if your 3D program doesn't have this feature, then the glow can be created later by rendering out the bolt flash only and compositing a blurred version on top of the main scene animation. See the final files Bolt.c4d and Bolt.3ds on the CD.

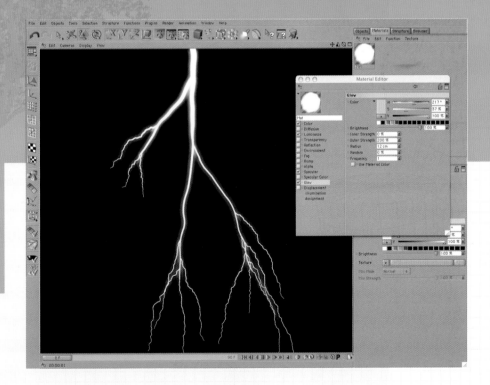

Stars and planets

So far, most of the sky-making techniques have involved daytime environments and those located on the surface of a planet. A night sky will obviously need a different approach, especially if you want to have a star-studded backdrop. Unlike a simple skydome background, a starry sky contains very fine detail—stars—which need to remain pin sharp in the image. If using a skydome object, such as a sphere, you would need a very large bitmap image to cover the whole sky, probably around 9000 pixels x 4500 pixels, in order to maintain the stars' sharpness. It's unlikely, though, that during an animation a camera will take in the whole sky, so a smaller map can be used.

2 We'll create our image for a still image or animation in which there is no camera movement, if you want to create a background for an animated camera adjust the size of the map accordingly. Our image will be for a PAL (phase-alternating line) resolution video sequence, so all we need to do is create a planar backdrop image at PAL resolution. Here's our starting point, a 768 x 576 pixel file in Photoshop.

1 If you want a realistic sky map, then you can download a high-resolution one from www.oera.net/How2/TextureMaps2.htm that is a good start, but it still might be too small to get optimum results with. The best way then is to make one by hand in Photoshop.

3 To create a starry sky, the image is first filled with black, then the Noise filter is applied, set to Monochrome, in Gaussian mode with a value of about 20 to fill the image with fine white specks.

4 To make a more starlike image, Levels is used with the white and black point sliders pulled inward to make the brighter specks brighter and the fainter ones fainter. You can control the density of the stars using Levels alone.

5 Next, add "constellation" stars, the few very bright stars in the sky, or the odd planet or two by hand using a hard round brush of varying size and color, painting single clicks where you like—you may want to use actual constellations.

6 This image can be used as the backdrop for the main scene as it is, but it's not very realistic. To fix this we have lightened the black in the sky image using a gradient to simulate sky glow from the atmosphere. See the file StarrySky.PSD on the CD.

Storms and tornadoes

A tornado is a funnel of spinning cloud that stretches from the cloud layer to the ground, so creating one in 3D is not a very easy thing to do. There may be many different methods for creating a tornado, or twister, but probably the best way, especially if you're creating an animation, is to use a particle system. Particle systems are a special feature used to create swarms of points or objects in many 3D applications and can be used to create effects such as explosions, fireworks, smoke, or sparks. We'll use Maya's particle system to make a tornado.

1 Firstly, rather than emitting particles from a single point, we need to create a surface in the shape of the tornado from which particles will be emitted. This cone-shaped surface can be made in a variety of ways. Here in Maya, we've extruded a circle along a line and scaled the extrusion to flare it at one end.

2 Next, we add the particle emitter set to emit from the selected surface, and we reduce the speed of the particles to zero so that they stay on the surface. The particle type is set to Clouds in Maya, which displays the particles as circles in the editor, but will render them as little puffs of cloud in the final image. The surface itself is not needed, so can be hidden from rendering.

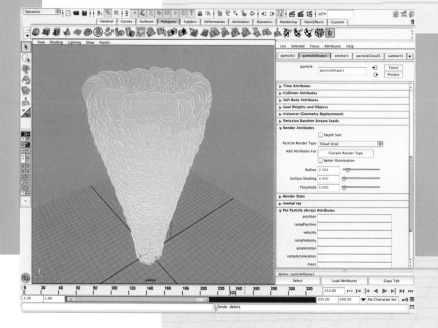

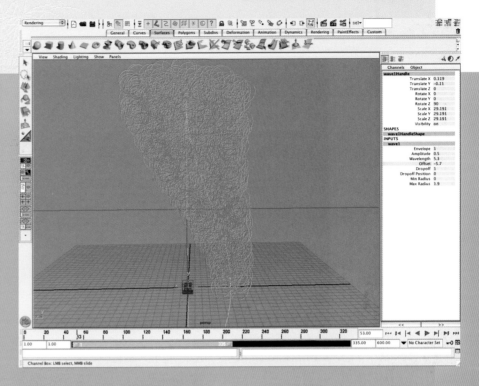

3 A wave deformer is applied to the cone surface to bend it at its base. This deformer can be animated along with the surface's position to create the weaving, bending motion of the twister.

The surface can also be rotated along the Y-axis to make it spin, and the particles will take on some of this velocity as they are created.

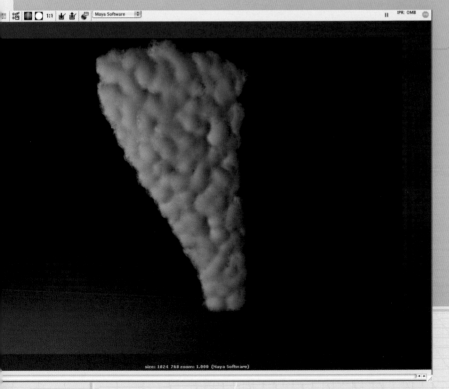

4 Using a volumetric shader, the twister's particles can be rendered to look like puffs of cloud. It's not a perfect solution for a still but it will work quite well once animated.

Smoke

Other atmospheric effects that you might want to create are dust storms, smoke, and other localized dust or vapor-like effects. As with the tornado example, smoke can be simulated using a particle system. Particles themselves do not render, they are simply points in space that are born, travel—due to some initial velocity or force acting on them—and then die. You can attach renderable objects to particles, such as a sphere, to make the swarm of particles visible when rendered, and texturing the sphere can help to disguise the fact that you're using geometry. An alternative way of simulating smoke with particles is using something called sprites. A sprite is a single bitmap image attached to each particle in a particle swarm to create the impression of much denser, or extended particle objects. The sprites are set to always face the camera so that their 2D nature is less apparent. In most 3D programs you can use a flat polygon textured with an image as the sprite, and this method can work well. Alternatively, texturing a sphere can be a more realistic solution because you do not then need to orient them toward the camera, though the polygon count will be many times that of a system using simple planar polygons.

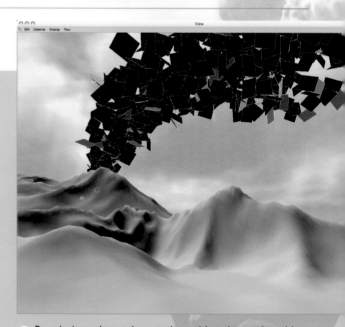

2 By assigning a planar polygon to the particle emitter, each particle is replaced by an individual instance of the polygon plane. Different 3D programs handle particle instancing differently, but the basic concept is the same. At the moment, each polygon is set to the orientation of the emitted particle (the particles usually have position and rotation data) which is not very useful for creating a sprite effect.

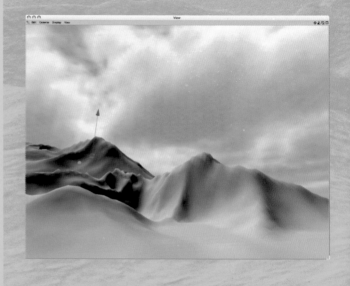

1 Here's the scene, a distant volcano that is using a simple particle system as the basis for the plume of smoke. As you can see in this OpenGL image, the particles themselves are just points in space, and rendering the scene as is would result in no visible plume.

3 By making the polygon plane aim at the camera all of the time, we have the perfect geometry base ready to be textured with the sprite images.

4 For the sprite image, we've chosen an image of a volcanic eruption plume and opened it up in Photoshop. We won't use the image as it is but will instead convert it into a random smoky texture using Photoshop's Pattern Maker filter.

Smoke

5 A small section of the plume is selected to use as the pattern source in the Pattern Maker interface; then the pattern is generated using a smoothness value of 3. The resulting pattern is a fairly decent random smoky texture that we can use for the sprite. However, using it like this is no good. We must also make an Alpha channel to mask out the edges of the sprite; otherwise, the fact that we are using square polygons will be obvious.

6 Here's the mask for the sprite. It's a simple radial gradient applied as a layer mask to knock out the edge pixels of the layer. Our destination 3D program reads Photoshop format files, so we can save out the sprite as a single image file. The last step before saving, though, is to convert the file to grayscale so that the smoke is gray instead of blue.

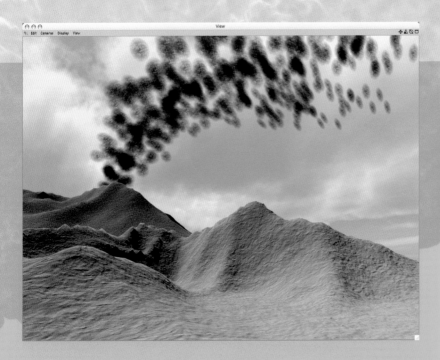

7 The sprite image is then applied to the plane material in the both the Color channel and the Alpha channel (or in other applications the Transparency channel). Several things are wrong, though. First, the scale of the polygons is too small; the planes need to expand as they go. Second, because of the light direction, the planes are not illuminated. Generally sprites need to be self-illuminating, so we'll need to fix this, too.

8 Setting the scaling option in the particle emitter causes the particles to expand over their lifetime, which creates a better-looking plume effect. Also, when material luminosity is enabled, the sprites are no longer black. The overall brightness of the plume can then be set using the Luminosity channel of the plane material.

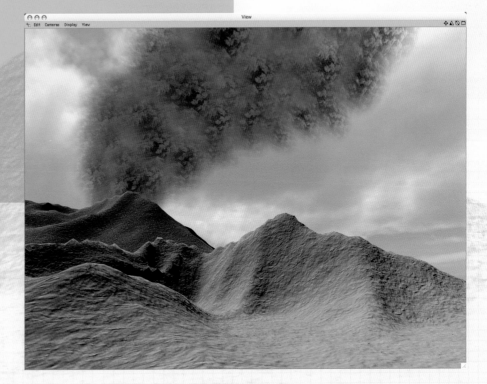

Smoke

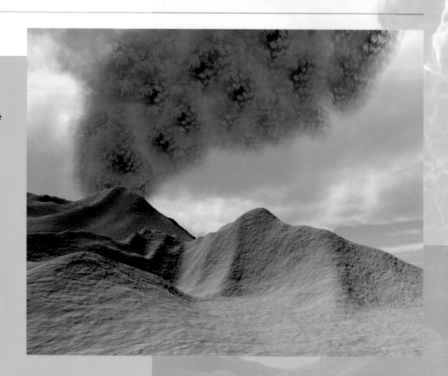

9 This solution is okay, but the lighting of the plume is not very realistic. Actually, sprites are more suited to much lighter smoke and dust clouds. Volcanic plumes are so dense that the cloud acts as if it were a near-solid surface with proper diffuse illumination. However, the volcanic plume is a good way to demonstrate the effects, and limitations, of sprite-based particles.

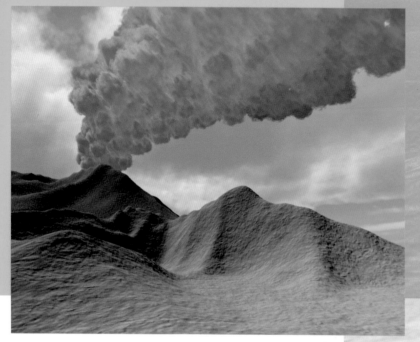

10 For true cloud-like rendering, you should use a volumetric rendering system. This kind of simulation renders clouds as if they were true bodies of dusty or smoky material in the atmosphere. Because you can vary the density of the volume, you can achieve anything from pale smoke to dense pyroclastic plumes with correct surface shading. The limitation is that your 3D program must support this kind of volumetric effect or have an available third-party plugin that can add the feature to it.

Here's a typical example of a volcanic plume rendered using a volumetric plugin. Notice that the material is illuminated by the scene lighting and therefore appears to be much more realistic. The file can be found on the CD as volcano.c4d.

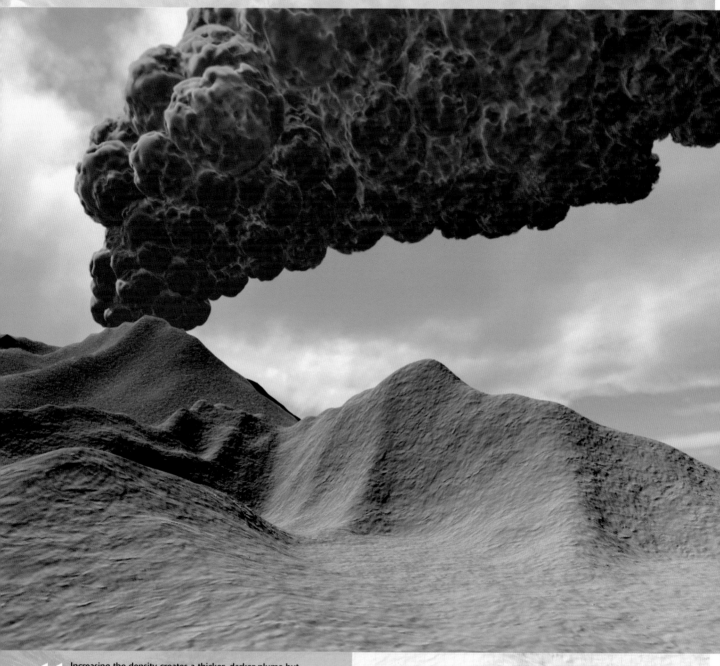

11 Increasing the density creates a thicker, darker plume but actually renders more quickly. The more transparent the volume, the longer the render times because the software has to calculate "deeper" into the volume, so a more dense plume is less processor intensive. This is why sprites are much more economical than volume rendering for thin smoke and dust clouds.

Simple trees and plants

If you need many trees, something quick and uncomplicated, or maybe even a populated landscape for gaming or interactive use, then there is a simple trick you can use that keeps geometry to a minimum and looks fairly realistic. This method is good in detailed scenes, too, but should be restricted to middle and distant groups of trees. The only real limitation is if you want to view the trees from above; for all other viewing angles, this method can work wonders.

2 Another option is to buy a tree texture from a texture vendor or CD collection. For home use, you can simply try a Google image search, but bear in mind there may be copyright issues so be sure to check. Here's a tree texture we'll use, and its associated alpha mask.

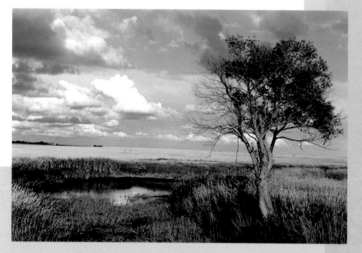

1 The first step is to get a decent image of a tree. The sure-fire way to do this is to take a digital camera out to a park or field and photograph some trees. Ideally use a zoom lens and stand away from the tree so as to reduce any perspective distortion. Try to get a lone tree against a blue sky, as this will be easiest to mask out in Photoshop.

3 In Cinema 4D, we first create two planes and position them perpendicular to each other in a cross arrangement.

4 The tree image is loaded into the Color channel of a new material, and the material is applied to both of the planes using either UV, or flat projection mapping. So far, so good. Now, we need to clip away the unwanted parts of the texture so that it is invisible, leaving the tree part of the texture intact.

5 Some programs have a Clipping channel that allows you to clip away unwanted geometry using a mask. You may also use Transparency, or, in Cinema 4D's case, the Alpha channel of the material. This is where the tree mask image is loaded.

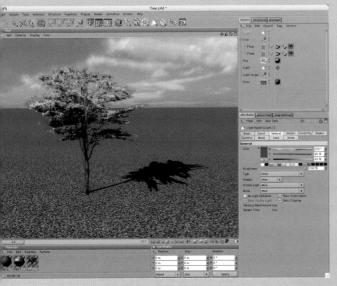

6 The tree trunk does not line up where the planes intersect, but this can be easily fixed. One plane is flipped 180 degrees around the vertical axis (to prevent the same part of the tree texture appearing on both sides of the X), and then moved so that the trunk intersects the trunk on the other plane correctly.

Some luminance is then added to the tree material. Even when rendered with shadow casting, the tree is fine for low-resolution work.

7 The great thing about this technique is that there is little geometry to speak of, so you can duplicate or clone the trees and distribute them around a scene without adding too much computational overhead.

Procedural trees and plants

Arguably the best (and certainly the easiest) way to add realistic trees and plants to your 3D environment is to use a dedicated simulator. These are often built in to landscape programs as a matter of course because foliage plays a big part in most landscape images. Both Bryce and Vue have tree/ foliage creation sections that offer decent results with little effort. Vue also lets you export the model, which is great if you want to then incorporate these models into another 3D program.

1 In Vue, you can add trees and foliage by simply clicking the Solid Growth button. This adds a random tree or plant to the scene. You can click as often as you want to add as many of these items as you need, and each one will be "grown" digitally to be unique.

2 The system works well, and bases each new plant or tree you add on the previous species added. If you want a different type of plant, then you can select them from a preset library to change the type.

3 In the Pro version of Vue, you have the additional benefit of being able to edit the foliage that you create. This is great if you have a very specific need in mind, or perhaps you need a particular look for a tree or plant, but it can be tricky to get just the right shape that you want because the editing controls are specific to the species of plant selected. You can, though, apply your own textures for the leaves, which is handy.

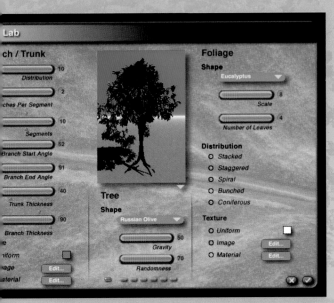

4 Bryce also has a tree system, though it's a little less realistic than Vue's. The editing interface is fairly good, though, giving you many options for changing the look of your tree. The downside here is that the tree is rendered using a "metaball" type of geometry, meaning that you can't export the tree for use elsewhere.

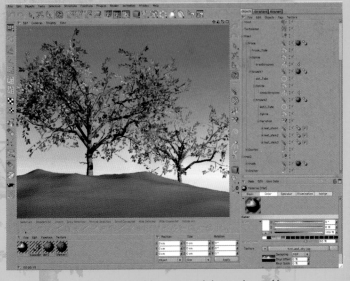

5 X-Frog is a plugin (and a standalone program) that can be used in a "host" 3D program such as Cinema 4D or Maya. This route does give you much more freedom, as long as you use the host program in the first place, but these programs can also be quite complex to use.

Complex trees and plants

If you intend your scene to have trees, plants, or other kinds of vegetation close to the camera, then you will need more complex models that will look better when viewed up close than the simple textured plane method allows. This means that you will have to build these models manually if you don't have access to a dedicated foliage simulation system or plugin, or you don't want to pay for your models, but making them is not as difficult as it might seem.

1 In this example, we'll create a small leafy plant a bit like a hosta, which is made roughly from rings of similar leaves. The first step is to make a "master" leaf. Starting with a flat polygon plane divided into 3 x 4 polygons, we select and delete the four corner polygons.

2 This flat polygon object's points are moved to make a rough leaf shape with a small stem. It doesn't have to be even, in fact it's better left a bit rough so that the leaf looks more organic. Next, the object is "sliced" down the middle in both directions to add some extra rows of points.

3 The center row of points is selected and rotated in a side view to create a gradual V-shape to the leaf that increases toward the stem. It doesn't matter that the leaf looks a bit angular at the moment because it will be converted to a Subdivision Surface object soon.

4 Before the leaf is duplicated, a texture map is added to the leaf so that all of the copies will also have the leaf texture, saving a lot of work later on. In order to get the texture to fit properly, UV mapping is used. Here you can see how the UV points of the model (which correspond to the polygon's points, though are actually different) have been moved so that they lie inside the leaf image.

Complex trees and plants

5 The leaf is turned into a smooth object by enabling Subdivision Surface mode—in LightWave this is called SubPatch mode. To complete the leaf model, LightWave's Bend tool is used to bend the leaf over in a natural looking curve. The stem points have also been moved to lengthen the stem.

6 The leaf can now be cloned/duplicated to make the first layer of leaves. LightWave's Clone tool is used here: the number of leaves is set to 5, and rotation to 60 degrees, giving us 6 leaves in total. The clone operation also moves the leaves a little in the vertical direction so each leaf is slightly higher than the next.

7 To add some extra variation, you can also select each leaf and then rotate and scale it individually. This set of leaves can then be copied (in a new layer in LightWave), rotated, scaled, and moved upward to create the second tier of leaves.

9 The Clone feature is applied once more to the new leaf to give another ring of 6 leaves. Again, it's duplicated, moved, rotated, and scaled to fill in the gaps and finish the plant. If you really want to be fussy, you can tweak the leaves one by one or, as here, apply a small amount of jitter (a function that applies noise to the point positions) to roughen the model. The result is a fairly decent plant model. This model is on the CD as Hosta.lwo.

8 The third tier of leaves needs to be a little different, so a leaf is copied and edited to make it smaller, more curved, and with a longer stem. It's also moved inward toward the center to help close the hole in the middle.

10 When rendered, the resulting plant is fairly convincing even when rendered with a very simple material as shown here. The rendered image makes use of Radiosity to provide more accurate shading and lighting.

Adding creatures

In addition to flora, you'll probably need to include some fauna, but creating animals for your scene can be pretty tricky and moves into the realm of advanced modeling. However, you can make plenty of different animals that are not that tricky—such as insects, which make themselves easier to build by virtue of their jointed exoskeletons. Larger animals, such as birds, are a little trickier, and quadrupeds are trickier still because their skeleton joints are covered by a layer of smooth muscle and skin and are often furry—and fur requires a very specific and advanced hair and fur rendering system, often found only in expensive high-end software. However, for medium-distance animals, you can get away with using ordinary texture mapping for animal surfaces because hair or fur is not really discernible at a distance.

1 Insects are useful compositional elements in your scene because you can place them near the camera, perhaps on an overhanging branch or leaf, to enhance the sense of scale in an image. They're also a good place to start modeling because they are relatively simple. Here, we'll look at making a simple spider. First, get some spider reference images from the Internet (e.g., using Google Image Search www.google.com).

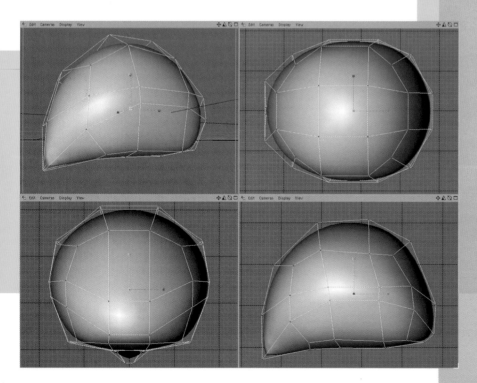

2 The spider's abdomen is modeled from a sphere, or you could use a subdivided box, which was converted to a subdivision surface to smooth it. This kind of modeling involves just moving the points, polygons, or edges until the right shape is achieved.

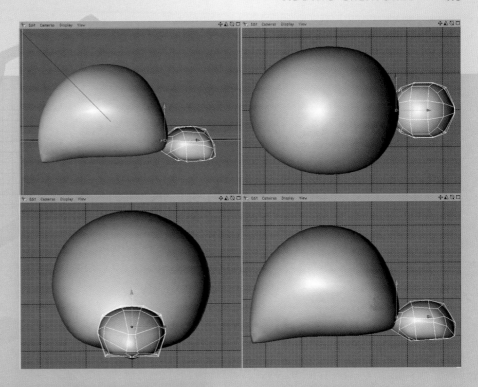

3 The cephalothorax (the combined head and thorax unit) is a similar structure that's positioned in front of the abdomen. To make the joints work properly, and to aid in posing the spider later on, the pivot point of the abdomen is moved to the join between the two parts of the body.

4 The legs are simply made from four cylinders that have also been point-edited to match the reference images roughly. Note that the leg sections flare out where the next section joins to it. An example leg model can be found on the CD as leg.c4d.

Adding creatures

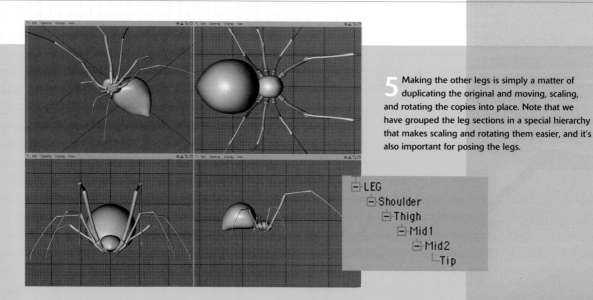

5 Making the other legs is simply a matter of duplicating the original and moving, scaling, and rotating the copies into place. Note that we have grouped the leg sections in a special hierarchy that makes scaling and rotating them easier, and it's also important for posing the legs.

6 The head details don't have to be very accurate, unless you want them to be, so the fangs and eyes are created again from simple sphere primitives. The fangs are polygon spheres that have been point-edited and converted to subdivision surfaces.

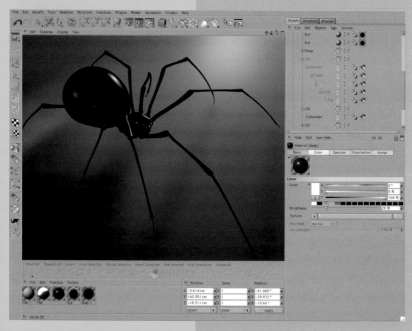

7 Texturing the spider is also quite easy to do, as long as it is not meant to be the focus of the scene. This spider is supposed to look like a black widow, although it's far from biologically accurate. Also, simply giving the spider a shiny black material doesn't work too well. The detail of its shape becomes lost because of the darkness of its surface.

8 The problem becomes even worse if the spider is to be seen in front of a dark background or surface. Here we've added some environment reflection (using an HDRI image on a skydome) and a fractal bump for the spider's exoskeleton. As you can see, the spider is very hard to make out.

9 The secret is to use something called a Fresnel shader, also known as edge falloff, in the Luminosity or Ambient channel of the material. This shader adds a light edge to the spider's surface, making it more visible, and also mimicking the real-world phenomena of dust and hairs on the spider's body that catch the light.

10 Further detail can be added to the spider using a fractal noise shader to mask both the reflection and the luminosity with a mottled pattern. This gives the spider's surface a more organic and varied appearance. Note that all we are doing is hinting at how the spider would really look, but even these small cues will help to make it look correct when used in your scene. The final spider object is on the CD as BlackWidow.c4d.

Simple man-made structures

Another kind of object that you will likely want to add to your scenes are man-made structures such as buildings, ruins, or roads. These kinds of objects can be made using polygon-modeling techniques. Nonuniform rational B-spline objects (NURBS) may be used too, but because of their natural tendency for smoothness, they will require special attention to get them looking like stone, wood, or other kinds of industrial or building materials. Polygons are not better than NURBS for this; it's just that they usually require less work because of their angular nature. In this example, we'll build a dam, an object that is usually well integrated with its surrounding environment.

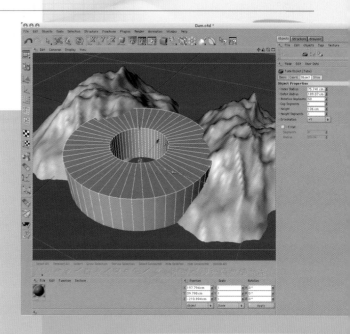

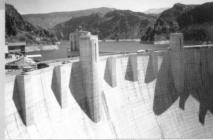

1 The first step is to create the valley landscape, which we do using two procedural terrain objects placed a little apart to create the eroded river valley that will be stoppered by the dam. In this case, we will be creating the Hoover Dam in the United States. Once again, use Google Image Search to find reference photos, even though the model that you make doesn't have to be an exact replica.

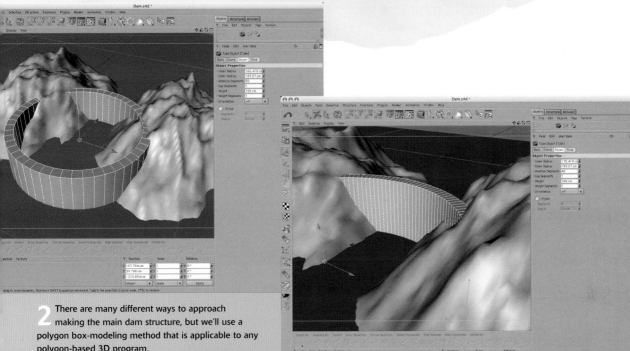

2 There are many different ways to approach making the main dam structure, but we'll use a polygon box-modeling method that is applicable to any polygon-based 3D program.

 The base geometry is created from a primitive. In Cinema 4D, this primitive is a tube (like a hollow cylinder), and its Slice option is enabled to produce a small section of its wall.

3 The front wall's bottom row of points is selected and moved forward, creating the slant at the front of the dam. However, this should be curved, not straight, so the wall is sliced three times using a knife tool, and these rows are moved to create a slight bowl to the dam.

4 Because only four rows of points are used, the curve of the wall is too coarse. This can be fixed by converting the object to a subdivision surface.

 The top cap of polygons is then selected and "chipped off" from the main object to create a second separate model that is not smoothed. This prevents the top of the dam from being rounded off as well.

Simple man-made structures

5 The strip of polygons that will form the road along the top of the dam is extruded several times to make the road detail. First, the polygons are extruded inward only (with no offset), and then they are extruded downward only, then inward again to make the sidewalk, and finally downward a tiny bit to make the curb.

6 The structure is refined with the addition of some simple extruded cubes that are set into the dam at regular intervals.

7 Where the road meets the mountain, we can create a tunnel so that the road carries on uninterrupted. To do this, a cylinder is positioned where the tunnel mouth is to appear, and then it is cut from the terrain object using a Boolean subtraction operation.

8 Next, some towers that are built in the lake behind the dam and connected to it are added. These are made from a cylinder with a domed end cap whose circumference polygons have been extruded in strips to create detail copied from the Hoover Dam. There are four of these, so they can be easily duplicated to make the full set.

Note that the extra terrain behind the dam wall is also made by instancing the two main terrain objects. These have just been rotated 180 degrees so that you don't notice that they are the same objects.

9 The final step is to create the two bodies of water, which are simply polygon planes. However, the top water plane needs to be cut away so that it looks like the dam is holding back the water. This can be done either manually, by deleting polygons and moving points, or more efficiently by using a Boolean operation (the large cylinder in the image) to cut away what isn't needed automatically. All that is then required to complete the scene are some textures and lighting. You can find this model on the CD as dam.c4d.

Simple lighting—ambient

Although you might see the sun in a 3D landscape scene, it's not necessarily the same thing that is casting light and illuminating everything. As we've seen in previous chapters, you can use a glowing light to simulate the sun's orb in the sky, though this has nothing to do with the actual light itself. In a 3D program, light sources are invisible—if you point a camera directly at a 3D spotlight, for example, you won't see a bright object in the center of the view, you have to create one explicitly. In a dedicated 3D landscape program, it can be easy for newcomers to not realize this fact because the visible sun and the illumination for the scene seem to be the same. They are merely two features linked for convenience and comprehension. To help make better images, it's a good idea to learn a bit about how lights in a 3D program actually work.

1 In a 3D landscape program such as Vue, there are usually two kinds of illumination at work by default. There is the sun, which provides the main direct illumination, and also global ambient light that helps to "fill in" the shadows. Note that in this image the sphere is lit by direct illumination from the sun's light, and also by a good bit of ambient light that has the effect of lightening the shadow areas.

2 Turning off ambient light removes the fill illumination, resulting in stark, black shadows. Obviously, some amount of ambient light is desirable, but how much is right?

3 The simple answer is that this kind of global ambient light is not good in any circumstance where quality and realism are required, but often there is no other alternative unless you have access to Radiosity rendering (more on this later in the chapter). A good way to get around this is to use as little ambient light as possible, and instead to use a dedicated fill light where necessary. Here, a point light has been placed below ground level (with shadow casting turned off) to simulate bounced light from the floor onto the underside of the sphere. The effect is subtle but worthwhile. This example can be found on the CD as fill.vue.

4 In a more complex scene, you may need to add several such fill lights to localized areas. When you're illuminating more complex objects, the benefit of the subtle fill becomes more evident. Here, the fill light is tinted the same general color as the floor from which it is supposed to be reflected.

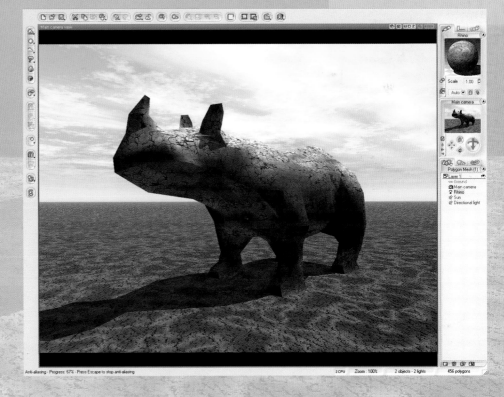

Realistic scene lighting—faking radiosity

As we've just seen, global ambient light is generally a bad thing and should be avoided if possible. Using carefully placed fill lights can work wonders on small, foreground objects, but for more widespread scenes with lots of detail, the work required will often outweigh the benefit. However, there is a way to get good large-scale ambient lighting that comes close to proper Radiosity rendering, yet does not require a 3D program with Radiosity.

2 Using a fill provides illumination where you want it, but it lacks realism, and placing lots of strategic fill lights is a time-consuming task. Instead, global skydome lighting can be simulated using a hemispherical array of spotlights. Here you can see the array of about 30 lights. Note that the lights are encompassing the main focus of the scene, and pointing toward the center.

1 Here's a simple sphere to illustrate the effect clearly—without any ambient light, the shadows are totally black. We need some "bounced" light from the floor to illuminate the underside of the sphere.

3 Each light is an instance of a single main "controller" light whose brightness is set very low, about 3%, and given a blue tint. The result is good, but could be better. The reason is that there is no shadow casting for the dome lights.

4 Enabling soft shadows for the dome lights in the scene does increase rendering time, but it's worth it. However, because there are so many of them, you can get away with a much smaller shadow map size—perhaps 250 pixels square or less. The result is a very nice, realistic soft shadowing. Note that the lights also have their specular highlight casting disabled. This example can be found on the CD as LightDome.c4d.

5 Copying the light dome into the dam scene results in a dramatic improvement in the scene lighting. Without the dome, and using a single ambient light, the scene loses a lot of shading detail in the nooks and crannies, and looks flat. With the dome in place, the render is dramatically improved. This model can be found on the CD as DamLighting.c4d.

Radiosity rendering

Radiosity is a rendering technology that has, in recent times, become an indispensable tool for the 3D artist who needs to create accurate scene lighting quickly and easily. There are a number of different technologies involved, and you may hear the terms Global Illumination or Final Gathering used, but in this book we'll use "Radiosity" as an umbrella term for all of them. Basically, Radiosity calculates interobject illumination, or the scattering of light in a scene. In reality, light doesn't just stop when it hits a surface, as it does in a 3D program, some of it is absorbed, and some is bounced back until it strikes another surface and so on until all the light has been absorbed. In exterior scenes, direct sunlight is augmented by diffused light streaming down from the dome of the sky (which is sunlight that has been scattered by the atmosphere), and we have seen previously in this chapter how to recreate this ambient light by brute force. However, Radiosity rendering does it all for you.

1 As we've seen before, rendering a scene without any ambient light results in unrealistic shading with areas not directly lit by the main light being rendered totally black. In reality, light will bounce from surface to surface, producing a scattering effect that helps fill in these dark areas. Additionally, the dome of the sky provides illumination in a hemispherical pattern giving further scattered light.

2 Radiosity is a rendering technology that simulates this phenomena, and rendering with it enabled immediately gives the scene more life and realism, although it does take longer to render. Here, simply enabling Radiosity does not give the expected warmth because there isn't a skydome object in the scene. To get any bounced light at all, the Radiosity brightness is boosted to 300%, and the main light, to 165%.

3 The thing with Radiosity is that you need to model the parts of the scene that cast the extra light, even though they may not be seen directly. Here, you can see the hemispherical skydome object that has been added and that is given a sky-blue, luminous material. Note that it is also set to not cast shadows so that it doesn't interfere with the main distant light source.

4 Rendering again with Radiosity, you can see the dramatic difference that the addition of an encompassing luminous skydome brings. However, the settings are now way too intense, making the scene look washed out and totally overlit.

Radiosity rendering

5 Returning the Radiosity and main light brightness to 100% produces a much more realistic scene illumination. Notice that the skydome produces a global ambient light that fills in the shadow areas, but it does so taking into account the blocking of the light that is caused by the geometry in the scene.

6 To get a more accurate look still, the main light's shadow mode can be changed from hard to area shadows, producing a shadow that become softer as the distance between the object casting the shadow and the object that receives it increases.

7 Another thing to change is the color of the skydome. At the moment it is uniformly blue, but real skies have a gradient color that is generally darker and bluer at the zenith and lighter and paler at the horizon. It's interesting that what seems to be such a simple alteration to the skydome material can produce a much more realistic render.

8 The variation in scene lighting is limitless using just these two light sources. In a very brightly lit summer scene, you might want to increase the key light brightness and reduce the ambient light. This simulates the effect of our eyes accommodating the brighter light values by reducing the pupil diameter and letting in less light—thus the low level ambient light is pushed further toward black, but it doesn't disappear.

9 At dusk or dawn, the sun is low on the horizon, turning more orange, red, or pink, and the sky's color has more influence than normal, actually dominating the scene lighting. Here, the sky gradient has been altered to add some pink, and a deeper blue, while the sun's brightness is reduced and its color also changed to an orangey pink. This file can be found on the CD as Hosta2.c4d.

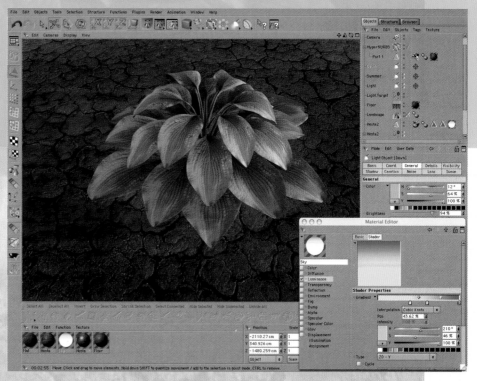

Working with lights

Lights are important elements of any 3D scene, so you should learn how they work and what the different light types do. Unfortunately, it's easy to forget that landscape-rendering programs actually have lights other than the default sun. You can get much done with just this light, but what will make your images special, and better than those that 3D landscape programs can quickly churn out, is the intelligent placement of additional lights.

There are broadly three types of light, distant (like the sun, also known as parallel lights), point, and spot. There is a fourth kind of light called an area light (and its cousin the linear light, which is like an area light but stretched only along one axis, like a fluorescent tube), but these lights are usually only available in the higher-end 3D packages.

2 Moving a point light farther from the object makes the shadow resemble those of a distant light more as the distance increases. In fact, a distant light is much like a point light that has been moved an infinite distance away.

1 The point light is a very useful type of light that emits light rays in all directions from a single point in space. Note the way that the shadows cast by a point light taper outward getting wider the further they are from the object casting the shadow.

3 A spotlight is like a point light, except its illumination is restricted by a cone whose wideness can be changed from very narrow to very broad. This makes spotlights good for focusing light in specific places. Like point lights, spotlight shadows flare out the further they are from the object casting the shadow.

4 Increasing the spotlight's cone angle widens the focus of the light. Notice that the circle of light created by the spot has some additional properties that can be changed. Here there is no falloff, and the edge of the cone is hard.

5 Increasing the falloff varies the intensity from the edge of the cone to the center, and also the edge itself can be softened. This makes spotlights very flexible devices for illuminating specific areas and for "painting" the scene with light.

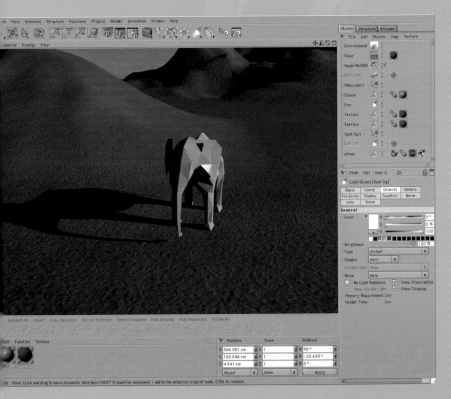

6 3D landscape applications don't usually have a distant light other than the sun, so here is the same scene in Cinema 4D, lit with one of its distant lights. As you can see, the shadow does not flare out at all.

Special lighting effects

Lights can be used normally to provide illumination, but they can also be used to add special effects to a scene. Usually this involves making use of their glow or lens flare facility, though if the program is advanced enough there may be volumetric glows on offer as well. Volumetric effects are special rendering algorithms that produce phenomena such as fog and mist, but not the usual kind that you find in the atmospheric settings of a landscape application. Volumetric lights cast glows that have real volume and can be obscured by objects in the scene, casting shadows through the glow. This is a great way to create dramatic effects such as light rays through mist or fog and has been used to great effect by many 3D artists.

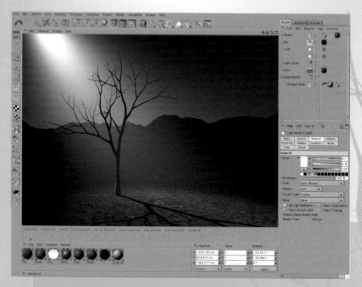

1 In this scene, a spotlight is being used to cast a glow and is intended to mimic light rays through the mist. As you can see, the glow is not truly volumetric because the tree is not casting any shadows through it. This kind of nonvolumetric glow is handy for other effects and renders very quickly.

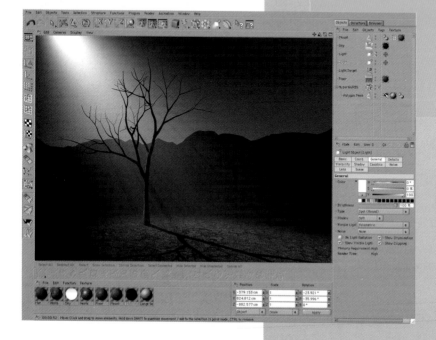

2 With volumetric glow enabled, you begin to see the shadows as faint streaks through the mist. However, the spotlight is very close to the tree, so it looks too much like a spotlight and not a natural effect.

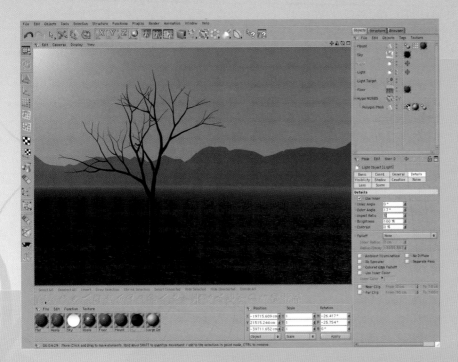

3 Usually, parallel or distant lights can't cast volumetric glows because they have no location, only a direction (they are supposed to be infinite light sources after all). But by moving the spotlight very far away from the scene, 50,000 units in this case, it becomes more like a distant light.

The glow distance also must be increased so that the glowing cone reaches the objects, which are now very far away from the spotlight itself. However, the cone is now so large that the tree can't cast shadows properly in the fog, and the rays disappear.

4 The solution is simply to narrow the cone, to a minute 0.5 degrees in this case. Because the spotlight is so far away, this cone angle produces enough spread by the time it reaches the tree to illuminate it normally. Because the cone is tighter, the volumetric rays can be rendered properly, too, and they are more parallel. Note that the reason for the rays rendering again has to do with the density of the volume samples. Generally, you want to keep the cone angle as tight as possible to maximize the sample density for shadow ray production. This rule should be the same in all programs that use volumetric lights. This file can be found on the CD as Large Dead Tree.c4d.

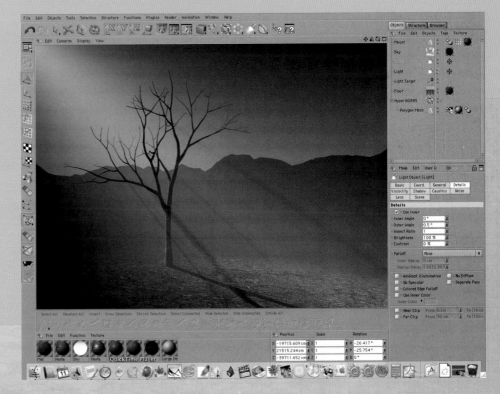

Importing objects

3D landscaping programs specialize in creating environments, and so tend to avoid offering general-purpose 3D modeling tools. Often all you will get are a set of primitives, such as spheres, cubes, and cones, that can be used to build fairly simple 3D structures. If you need something more sophisticated in your scene, like a detailed building, an animal, or anything that requires detailed modeling by hand, then you must build it in another 3D program and import it. Programs such as Vue and Bryce both let you import 3D models from other sources.

2 Here's the model imported in Bryce. It was exported from Cinema 4D as a DXF format model so that Bryce could import it. However, the model was not imported in a way that makes it easy to work with; it is only in two parts so, for instance, the windows are not separate objects, making it impossible to give them their own material.

1 This object has been downloaded from the Internet (from Turbosquid.com) and opened in Cinema 4D. The model is in 3DS format (.3ds), which is a format used by the old 3D Studio, now 3DS Max. As such, it cannot be directly imported into Bryce, which only supports DXF. Using an intermediary program like Cinema 4D, which can import and export a variety of 3D formats, is a good way to convert models to the desired format.

3 Bryce is not a polygon-modeling program and has no way to select and edit the polygons of a model, so you have to select and separate the parts of the model that you want to apply different materials to in another program before exporting it. Here, the windows have been selected and "split" from the main model into a separate object.

4 Now when this object is exported and reimported into Bryce, the windows can easily be selected because they exist as a separate object. Here they have been given a transparent and reflective glass-like material.

5 If you don't have another 3D program to help with file translation, there are a few relatively inexpensive shareware programs that will do the same job, such as 3D Object Converter, which has a 30-day trial and can be downloaded from the Web at http://web.axelero.hu/karpo/

Importing objects

6 Sometimes when you import an object into a 3D program, the object doesn't look like it should. Sometimes the model file might be corrupted, or there is an incompatibility between the two programs and formats you are using. Often, the exporting or the importing program doesn't have a very well-designed support for the particular file format, or they are of an older version of it. Sometimes there is just a weirdness that occurs between two programs that were originally never meant to "talk" to each other. Here, this rose object has imported okay except that the stem is not in the right place or orientation, though the scale of the various pieces seems fine.

8 However, on close examination there is another problem: the polygon object is not being smooth shaded properly resulting in each polygon face being visible as a facet. Sometimes this is desirable because you don't necessarily always want smoothed faces, for example on a model of a gemstone, but on this organic object, it certainly isn't acceptable.

7 It's a relatively simple matter to select the stem on its own (easy since it has been imported as a separate object) and reposition it by eye. Using a four view layout makes rotating the stem a lot easier since you can constrain the rotation depending on which view you use.

9 Most 3D programs offer you the ability to adjust the smoothing angle for proper smooth shading to be achieved. Here the angle is changed from a value of zero, which is why no smoothing was taking place, to 60 degrees.

10 Now when the rose is rendered, the facets are smoothed away resulting in an object that looks more natural. Note that the Smooth Shading Angle setting determines the angle below which the adjacent polygons will be smoothed. If the angle is above this setting, it will not be smoothed. Having this threshold is important because it prevents the software from smoothing where it shouldn't, such as between the faces of a cube, which has angles of 90 degrees between its faces. Also, note that the smoothing is not adding any extra polygons, it's simply smoothing the pixel colors to prevent an abrupt transition in the shading from one face to the next. This shading is often called Phong shading, after the man who developed the technology. There are other shading algorithms also common in 3D, such as Blinn and Oren-Nayer.

Compositing 3D objects

Compositing is the process whereby a 3D element is combined with a still image to make a seamless whole or composite, hence the name. You can do this by rendering out your 3D object and opening it in a 2D editing program such as Photoshop, and then placing the 3D render on a new layer on top of a background image. Because you can render out an Alpha channel along with the main color image, cutting out the 3D object from its unneeded background is a simple task. However, there's another way to create this same kind of composite directly in your 3D program.

1 Here's the object that we want to add to our photographic environment. It's a model of a jet fighter that was downloaded from the Internet.

2 To put the two together requires the background image to be loaded into the 3D program, either as a special background object or as a texture map applied to a large plane facing the camera. If using the texture map route, you will need to apply the image in the Luminosity channel (or in the Color channel with luminosity or ambient value of the material set to 100%). To prevent stretching or squashing of the background image, you must set the document's render resolution to the same as the background image (or at least to the same aspect ratio).

3 Our image is quite large, so the document is set to 1837 x 1115 pixels. So long as the aspect ratio remains the same (Y:X, 1837:1115 in our case, which is approximately 1.648:1), you can render out the final image at any size. Next, the scene is arranged. The fighter is duplicated twice to create a small squadron of planes, and the camera is then adjusted to compose the image.

4 Two lights are added. One is a distant light orientated to match the direction of light in the image. Its color can be set by sampling directly from the colors in the image itself. This is easy in Mac OS X using the default color picker, which has a sampling tool built in. On Windows, you may need to use Photoshop or some other application to sample the colors and write down the reading. Its brightness is set very high to give good contrast, while the second light is an ambient light again set using a sampled color.

5 Finally, rendering the image provides us with the clean composite of the 3D objects and the background without having to fuss with Photoshop.

Finishing in Photoshop

Though you can composite 3D elements directly in your 3D program, transferring the files to a 2D editing application such as Adobe Photoshop, Corel Paint Shop Pro, Corel Photo-Paint, or Adobe Photoshop Elements and compositing them there offers much more control. Aside from superior color correction and image adjustment tools, 2D bitmap-editing programs allow you a much finer degree of adjustment than 3D programs. The degree of fineness can be attributed to the fact that you are working in real time on a simple bitmap image as opposed to tweaking and rerendering in full 3D, the feedback loop of which is considerably long-winded.

1 Taking the fighter planes scene as a subject once more, we can render out the planes separately, but with their associated Alpha channels. The Alpha channel is simply a grayscale image that corresponds to the silhouette of the object in the scene. The planes' alpha looks like this.

2 Black in an alpha will become transparent when applied in Photoshop, while white will be opaque. Note that the Alpha channel also takes into account the transparency of the glass in the cockpit of the planes. This is rendered as a shade of gray, meaning that it will be partially transparent.

3 There are two main ways to render an alpha, although only the first may be available in some 3D programs. An Alpha channel can be rendered simply by enabling this feature in the rendering options and setting the file format to one that supports Alpha channels, such as 32-bit TIFF, PSD, and TGA. In this case, both the alpha and the color render is antialiased (smoothed), but this can cause complications later, as we'll see.

4 Straight alpha is a different way of generating an image and its associated Alpha channel. This mode only antialiases the Alpha channel itself, while the color image is rendered without antialiasing (actually it is antialiased, but the pixels' brightness values at the edges of objects are not attenuated). Note the jagged edge and odd colored pixels at the edges.

5 Opening the planes image in Photoshop, we can load the Alpha channel (which is in the Channels palette) as a selection, invert it, and delete the black background. In Adobe Photoshop Elements, you need to use the Select > Load Selection menu and choose the Alpha channel from the pop-up menu. Note that you'll also need to double-click the Background layer to convert it to a normal floating layer so that the black can be deleted.

Finishing in Photoshop

6 Unfortunately, there is a thin sliver of black along the edge pixels of the planes. The black is due to the planes being rendered on a black background, and because of the antialiasing that is used to smooth the appearance of jagged edges, some of the black pixels are merged with those at the edges of the planes. In Photoshop Elements, this is almost impossible to remove easily.

7 In Photoshop, however, there is a special feature designed specifically for this purpose. It's the Layer > Matting > Remove Black Matte option, which, when applied to a layer, eradicates the black line in one fell swoop. In order for it to do its job correctly, you must first load in the alpha mask as a selection, and then use this to delete the black background, leaving only the thin line of black pixels. The selection must also be deactivated before running the Remove Black Matte filter.

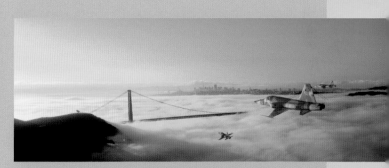

8 The black line problem is why the straight alpha mode is superior; when you load the alpha and use it to delete the black background, you are also transferring the antialiasing stored in the Alpha to the planes' edges, and because they contain none of the background color, they are perfectly regenerated. This works in Elements as well as Photoshop, or any bitmap-editing program.

9 The properly extracted plane layer can be easily dropped into the background image by dragging the layer directly over the image and dropping it, or by copying and pasting. Because we're using the same lighting scheme as before, the resulting composite is pretty good.

10 Correction is very easily accomplished in Photoshop or Elements now that the planes are on their own layer. The first thing we can do is introduce a little bit of haze to the panes so that the more distant ones appear slightly lower in contrast, and tinted by the haze. We can use the lasso to select one plane at a time and then fill a new layer with a bluish-gray color sampled from the image.

Finishing in Photoshop

11 To remove the overlap, the plane layer is loaded as a selection by command-clicking on it. This selection is first inverted by pressing Command-Shift-I, and then deleted. The layer can then be reduced in opacity to the desired level to simulate the effects of the haze. It really only needs to be a subtle effect to work well.

12 The same can be done for the other plane, again in a new layer, but this time a more orange color and a slightly higher opacity are used because it is more distant. The haze is not a constant color, which is why we need to select the right tint before applying it. Where the sunlight appears to flare toward the left of the image, the haze in the atmosphere scatters its orange/yellow glare.

13 If you want to add more planes, you can do so without going back to your 3D program and rerendering them—though this, of course, would be easy to do as well—just duplicate the plane layer (no need for any of the haze fills yet).

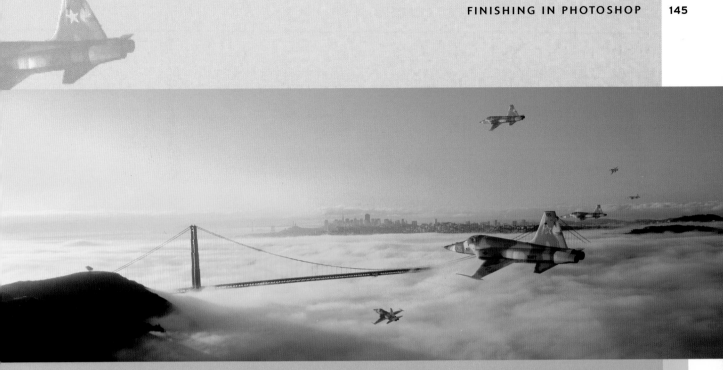

15 Finally, more fill layers are applied, each on its own layer, and adjusted to correspond with the apparent distance of the planes—the further back they are, the more haze they will have. This is why we didn't copy the haze fills along with the planes earlier; we didn't know the positions of the planes in the atmosphere and, therefore, the correct tint of the haze.

14 The individual planes can be selected and moved around to different locations. Using the Free Transform tool, you can shrink the planes and rotate them slightly to move them into the distance. Too many duplicates will look unconvincing, though, so always use caution when making direct copies.

Landscaping for games

Interactive 3D graphics is the core technology that drives many video and computer games. Producing 3D environments for games is something that is best done in a professional 3D development environment. However, there are games that let you design your own "levels," such as those based on the Unreal Engine by Epic Software. A game engine is the underlying software and technology that powers a game. Titles include the Unreal Tournament series, Id's Doom and Quake series, Valve's Half-Life, and so on.

Modifying games can be quite a confusing and complex business. It began with enthusiasts getting into the games and changing things armed with nothing more than a text editor. Since then, a whole industry and community has sprung up around the modification and customization of computer games, and, as such, the developers themselves support and encourage such activities. There are many custom "front-end" editors available for specific games or game engines that can be used to create game levels, and even the professional 3D graphics companies such as Discreet and Softimage have made game-modding software.

1 gmax is Discreet's game modding version of 3ds max. While 3ds max is geared toward advanced 3D graphics production, including game design, it costs a lot of money. gmax, however, is freely available and can be used to build levels and characters for game customization. Because it's free, you can't export the models that you make to formats other than those specific to the common game engines, and you certainly can't open anything you created in gmax in 3ds max itself. What Discreet gains by offering a program such as gmax for free is access to a huge pool of potential future 3D artists who may go on to work in the industry and buy 3ds max themselves. Even if they don't personally buy Max, the fact that there is huge pool of gmax-savvy 3D rookies seeking employment will influence the purchasing of companies who employ 3D artists, since the pool of talent will be biased toward 3ds max.

2 gmax has many of the tools available in the full version of Max, though in a more game-oriented way and without the more advanced 3D features that are not applicable to game level design, such as rendering. The program is designed only for modeling and texturing, since that's all that is required for level and character creation.

3 In order to use the content that you create in gmax, you need to export it to the game that you are designing for. Not all games support level modding with gmax, but those that do come with the correct plugin module, called a Game Pack, allowing you to export to that particular game engine.

Here, Microsoft's Train Simulator game's Game Pack plugin has been used, displaying an example model.

Landscaping for games

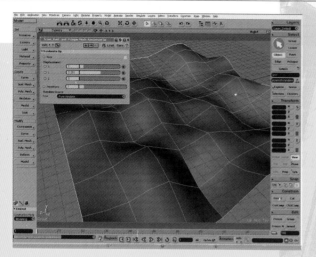

4 Softimage, the makers of the high-end 3D software Softimage|XSI, also produces a game-modding version of their product, called XSI Mod Tool. Like gmax, it's a dedicated game level and environment customizing application, but it has quite a few more features than gmax, not the least of which is full rendering capability, albeit watermarked with the Mental Ray/Softimage logo.

5 Actually, XSI Mod Tool is almost identical to their entry-level 3D package XSI Foundation, which in turn has about 80–90% of the features of the high-end and expensive XSI Advanced. The main modeling limit is that it's restricted to a maximum of 7500 triangles for exported objects. XSI Mod Tool prevents piracy of the application for general-purpose use by only allowing export to restricted formats, much as gmax does. It's a great way to get into 3D, though, because it's totally free, can save to its own format (for sharing files with other Mod Tool users), and lets you into a level of 3D previously unobtainable without purchasing the full software.

6 Softimage's XSI Mod Tool comes with the default dotXSI exporter, which is useful for connecting XSI Mod Tool with other programs via Softimage's dotXSI pipeline—though this method is aimed at high-end production work rather than game modding. Like gmax, though, game developers can produce "addons" or plugins to provide export routes from XSI to their game engine. One typical example is the VMF format exporter for Half-Life by Valve. Hammer is Valve's own 3D-modding software, and VMF is the format for it.

7 Despite the limited export options for XSI Mod Tool, the default dotXSI exporter means that it can be used to import models into the full commercial version of 3ds max. How? By the freely downloadable dotXSI plugin for 3ds max provided by Softimage themselves (www.softimage.com). Here's a model created in XSI and imported into 3ds max with the aid of the dotXSI plugin.

8 One of the great features about XSI Mod Tool is its Normal mapping function. Normal maps allow you to take a very high resolution, detailed object; capture all of the detail of the way that lights react with the geometry; and then save this into a special Normal map. This can then be applied to a similar model that has been reduced in polygon density ready for gaming use. When the Normal map is applied and used in a game engine that supports them, most of the detail from the original high-resolution model can be recreated on the low-poly model. This is usually used for creating extra-detailed characters, but it is also ideal for terrains.

Optimizing for the Web

Along with games, the Web is a medium that requires special care and attention when it comes to 3D graphics. The realtime nature of game graphics requires efficiency and economy so that the scenes played back will not burden the computer or console too much, and to make the gameplay as interactive and seamless as possible. On the Internet, not only are 3D graphics in real time, but they don't have the benefit of being delivered on a high-capacity medium like a CD-ROM, as is the case with a game. The nature of the Internet means that 3D files must be downloaded as and when they are required, imposing a further tier of economy over game graphics. With broadband Internet connections becoming standard, this bottleneck in the Web graphics pipeline is widening, but it's still there. Most of the technologies for web 3D graphics revolve around the delivery system and the economizing of the models and texture maps. File compression is one way to reduce the size of a model file, as is polygon reduction before the model is exported.

1 Landscapes and environments are useful for 3D Web graphics, games, visualizations, or virtual meeting places. When building landscapes for the Web, it's important to keep the polygon count as low as possible to speed download times. Here, a typical terrain object such as this that is suitable for multimedia work or print graphics would be far too big to download over even a broadband connection. For a Web site, every second that a user has to wait for something to download increases the chance that they will simply leave the site and move on to something better and faster.

2 Using polygon reduction inside your 3D program will help to make the models that you create for Web use smaller. Here, using an 80% reduction strength, the terrain mesh has been reduced from 10,000 polygons to 3998. That's a good reduction, but it's still quite a hefty model for Web use.

3 Increasing the reduction power further, to 95%, decimates the mesh further still, though at the expense of quite a bit of the detail. The mesh now contains fewer than 1000 polygons. When exported as a polygon object in OBJ format, the file size is a very respectable 88k, as opposed to 860k for the unreduced mesh. However, you can't just export to any old 3D format for the Web, you must export to the format supported by your chosen Web 3D solution, of which there are quite a few.

ABOVE *Shockwave,* BELOW *Electric Rain*

ABOVE *Viewpoint*

4 There are numerous Web 3D solutions currently available, with no real consensus on which is the best, or the most popular. The bottom line is that any user of your site must also have the plugin to enable viewing of the 3D content. Companies producing such plugins and solutions include Viewpoint with their VET technology, Macromedia with Shockwave, and Electric Rain with Swift 3D. A visit to each site will give you a good overview of the state of play, but the whole topic of Web 3D is a book in itself.

Online resources

MAKERS OF 3D MODELING SOFTWARE

3ds max—www.discreet.com

Amorphium—www.eitechnologygroup.com

Carrara—www.eovia.com

Cinema 4D—www.maxon.net

LightWave—www.newtek.com

Maya—www.alias.com

Poser—www.curiouslabs.com

Softimage|XSI—www.softimage.com

trueSpace—www.caligari.com

MAKERS OF 3D LANDSCAPE SOFTWARE

ArtMatic Voyager—www.uisoftware.com

Bryce—http://bryce.daz3d.com

MojoWorld—www.pandromeda.com

Terragen—www.planetside.co.uk

Vue—www.e-onsoftware.com

World Construction Set—www.3dnature.com

MAKERS OF WEB 3D SOFTWARE

Shockwave 3D—www.macromedia.com

Swift 3D—www.erain.com

Viewpoint—www.viewpoint.com

MAKERS OF GAMES 3D SOFTWARE

gmax—www.discreet.com

XSI Mod Tool—www.softimage.com

MAKERS OF 3D MODELS, TEXTURES, AND PLUGINS

Dosch Design—www.doschdesign.com

Katachi—www.katachi.de

Paul Everett's Plugin Corner—www.tools4d.com

Turbo Squid—www.turbosquid.com

GALLERIES

3D Artists—www.raph.com

3D Buzz—www.3dbuzz.com

3DCommune—www.3dcommune.com

3D Excellence—www.3dexcellence.com

3d-io—www.3d-io.com

3D Links—www.3dlinks.com

3Dluvr—www.3dluvr.com

3Dtotal—www.3dtotal.com

3D World Magazine—www.3dworldmag.com

Amazing Terrains—www.amazingterrains.com

Android Blues—www.optidigit.com

Ashundar—www.ashundar.com

Avidflame—www.avidflame.f2s.com/home.html

Balaskas Arts—http://balaskas.homestead.com

Bernard Lebel—www.bernardlebel.com

CG3D—www.cg3d.net

CGTalk—www.cgtalk.com

Cocoonia—www.cocoonia.com

DigitalByNature—www.digitalbynature.com

Gorean Graphics—www.goreangraphics.com

Guitta—www.guitta.net

Help 3D—www.help3d.com

Kenneth A. Huff—www.itgoesboing.com

Philippe Bouyer—www.belino.net

Planit 3D—www.planit3d.com

Relief Shading—www.reliefshading.com

Renderosity—www.renderosity.com

Secret Morning—www.secretmorning.com

Solar Voyager—www.solarvoyager.com

TerraEscape—www.terraescape.com

Terrageo—http://pagesperso.laposte.net/betweenstrap/terrageo

TerraNuts—www.terranuts.com

Glossary

ALIASING

The jagged edge of bitmapped images or fonts that occurs either when the aliasing resolution is insufficient or when the images have been enlarged. This is caused by the pixels—which are square with straight sides—making up the image becoming visible. Sometimes called jaggies, staircasing, or stairstepping.

ALPHA CHANNEL

A place where information regarding the transparency of a pixel is kept. In image files, this is a separate channel—additional to the three RGB channels—where masks are stored.

AMBIENT

A term used in 3D modeling software to describe a light source with no focus or direction, such as that which results from bouncing off all objects in a scene.

ANTIALIASING

A technique of optically eliminating the jagged effect of bitmapped images or text reproduced on low-resolution devices such as monitors. This is achieved by blending the color at the edges of the object with its background by averaging the density of the range of pixels involved. Antialiasing is also employed to filter texture maps, such as those used in 3D applications, to eliminate signs of pixelation.

API (APPLICATION PROGRAMMING INTERFACE)

A layer of code, either built in or added to a computer operating system, which creates a bridge between an application (e.g., a 3D package) and a piece of computer hardware (e.g., a 3D graphics card). As long as both the software and the hardware support the same API, then neither needs to be configured to support the other, enabling many applications to run on many different types of hardware without any need for recoding.

AREA LIGHT

A special light type that emits from a 2D area rather than a single point.

ATMOSPHERICS

The simulation of the atmosphere of a planet using modern 3D technology, such as volumetric rendering, fractal cloud patterns, fog, and other ethereal substances.

AXIS

An imaginary line that defines the center of the 3D universe. In turn, the X-, Y-, and Z-axes (width, height, and depth, respectively) define each of the three dimensions of an object. The axis along which an object rotates is called the axis of rotation.

B-SPLINE

A type of curve, similar to a Bézier curve, but based on more complex formulas. B-Splines have additional control points and values, allowing a much higher degree of control over a more localized area.

BEVEL

To round or chamfer an edge. Can also mean to extrude a polygon along its Normal, producing bevels around its perimeter.

BÉZIER SPLINE

In 3D software and many drawing applications, Bézier splines, or curves, are represented as a curved line between two "control" points. Each point is a tiny database, or "vector," that stores data about the line, such as its thickness, color, length, and direction. Complex shapes can be applied to the curve by manipulating "handles," which can be dragged out from the control points.

BLEND

The merging of two or more colors, forming a gradual transition from one color to the next.

BOOLEAN

Named after George Boole, a 19th-century English mathematician. The term "Boolean" is used to describe a shorthand system for logical computer operations, such as those that link values (for example, "and," "or," "not," "nor," and so on), which are called Boolean operators). In most 3D applications, these operations can be used to join two objects together or to remove one shape from another.

BOUNDING BOX

A rectangular box, available in certain applications, that encloses an item so that it can be resized or moved. In 3D applications, the bounding box is parallel to the axes of the object.

BUMP MAP

A bitmap image file, normally grayscale, that is applied to a surface material. The gray values in the image are assigned height values, with black usually representing the troughs and white representing the peaks. When it is applied to a surface and rendered, the surface takes on an impression of relief.

CAD (COMPUTER-AIDED DESIGN)

Strictly speaking, any design carried out using a computer, but the term is generally used with reference to 3D design, such as product design or architecture, where a computer software application is used to construct and develop complex structures.

Glossary

CAMERA

A viewpoint in a 3D application that is defined by its position, angle, and various lens properties. Cameras are used to generate a view of a scene or object during either modeling or rendering. Cameras can also be moved to create animations, in the same way that a movie camera moves during a conventional shoot.

CARTESIAN COORDINATES

The coordinate system employed in 3D applications, which uses numbers to locate points in 3D space in relation to a theoretical point of origin where the three-dimensional axes all intersect.

CHANNEL

A bitmap image, or a set of parameters, used to define a component of a texture material.

CLIPPING PLANE

In 3D applications, a plane beyond which an object is not visible. Most 3D applications have a viewing cube with 6 clipping planes: top, bottom, left, right, front, and back.

COLLISION DETECTION

The ability of a 3D program to calculate the proximity of objects and to prevent them from intersecting.

CONCAVE POLYGON

A polygon whose shape is concave; that is, it has at least one interior angle that is greater than 180 degree. For example, a star shape.

CONVEX POLYGON

A polygon whose shape is convex, for example, a regular hexagon shape.

COORDINATES

Numerical values that define locations in 2D or 3D space.

DIFFUSE

A color texture map applied to a surface to define its colors when viewed in direct light, and how much of the light that hits that surface will be absorbed and how much will be reflected (i.e., how much of those colors we can see).

DIGITAL

Anything operated by, or created from, information or signals represented by binary digits, such as a digital recording. As distinct from analog, in which information is represented by a physical variable (in a recording this may be via the grooves in a vinyl platter).

DISPLACEMENT MAP

A grayscale bitmap image that operates similarly to a bump map, but differs in that the black, white, and gray values will affect the geometry of the surface underneath. Displacement mapping creates a more realistic texture than bump mapping at the cost of additional time spent computing the effects.

EMITTER

An object that emits particles into a scene. Emitters can be different shapes such as a point, a line, or even a surface.

ENVIRONMENT MAP

A 2D image that can be projected onto the surface of a 3D object to simulate an environmental reflection.

EXTRAPOLATE

Creating new values for a parameter that are based on the values that have gone before.

EXTRUDE

The process of duplicating the cross section of a 2D object, placing it in a 3D space at a distance from the original and creating a surface that joins the two together. For example, when extruded, two circles become a tube.

FACE

In 3D modeling, one flat "side" of an object (for example, one of the six sides of a cube).

FALLOFF

In a 3D environment, the degree to which light, or another parameter, loses intensity the farther it is away from its source.

FILLET

A curved surface that is created between two adjoining or intersecting surfaces. Fillets turn up most frequently in NURBS modeling.

FOLIAGE

Plants, trees, bushes, shrubs, flowers, grass, or any other kind of organic nonanimal life-form that is added to a 3D landscape scene. Foliage simulation tools are often included in many 3D landscape-specific rendering programs.

FORWARD KINEMATICS

Traditional animation is based on Forward Kinematics, where, for example, to make a character reach for an object, first the upper arm, then the forearm, and then the hand are rotated.

FRACTALS

3D programs use fractal algorithms to produce many different kinds of random, repeating, self-similar patterns. These are used to create things such as clouds textures, terrain displacement, and dirt.

FRAME

An individual still image extracted from an animation sequence. The basic divisor of time in an animation.

FRESNEL

An effect where the edge of an object brightens owing to an increased intensity of reflection along that edge.

FUNCTION CURVE

In an application, a user-definable curve utilized to control the speed, or intensity of motion, of an effect.

GEOMETRY

What 3D objects are made out of, or rather described by. Geometry types include polygons, NURBS, and Bézier patches.

GIMBAL LOCK

A situation in which an object cannot be rotated around one or more axes.

GLOW

A material parameter used to create external glows on objects. The glow usually extends beyond the object surface by a defined amount.

GRAVITY

A force used to simulate the natural gravity of a typical planet. Gravity is a constant force that pulls on dynamic objects in a scene.

HEIGHT MAP

An image used to displace or deform geometry. See *Displacement Map.*

HIDDEN SURFACE REMOVAL

A rendering method, usually wireframe, that prevents surfaces that cannot be seen from the given view from being drawn.

INTERPOLATION

A computer calculation used to estimate unknown values that fall between known ones. One use of this process is to redefine pixels in bitmapped images after they have been modified in some way—for instance, when an image is resized (called "resampling") or rotated, or if color corrections have been made. In such cases, the program makes estimates from the known values of other pixels lying in the same or similar ranges.

INVERSE KINEMATICS

Or IK for short. When animating hierarchical models, IK can be applied so that moving the lowest object in the hierarchy has an effect on all the objects further up. This is the inverse of how Forward Kinematics works.

LATHE

The technique of creating a 3D object by rotating a 2D profile around an axis—just like carving a piece of wood on a real lathe.

LAYER

Modern image-editing applications can separate elements of an image onto transparent layers, stacked on top of each other to form a composite image. By switching layers on and off, changing their order, or changing the way they interact with each other, a designer can rework the composite image in a vast number of ways.

MAP

An image that is applied to a texture channel of a material.

MATERIAL

The aggregate of all of the surface attributes for an object.

MEMORY

Typically, this refers to either dynamic RAM, the volatile random access memory that is emptied when a computer is switched off (data needs to be stored on media such as a hard disk for future renewal), or ROM, the stable read only memory that contains unchanging data (for example the basic startup and initialization functions of most computers).

MESH VERTICES

Vertices that are linked to form Polygon or NURBS (or other) surfaces.

MOTION CHANNEL

An animation parameter that controls how an object moves (for example, rotation X, Y, Z and translation X, Y, Z are all Motion channels).

MULTIPASS RENDERING

The process whereby a single scene is rendered in multiple passes, each pass producing an image (or movie or image sequence) containing a specific portion of the scene but not all of it (for example, one part of a multipass render may contain just the reflections in the scene, or just the specular highlights).

NORMAL

In 3D objects, the direction that is perpendicular to the surface of the polygon to which it relates.

Glossary

NURBS

Nonuniform Rational B-Spline. A B-spline curve, or a mesh of B-spline curves, that is used to define a line or a surface in a 3D application. NURBS surfaces require fewer points than polygon surfaces to model smooth flowing surfaces.

PARALLAX

The apparent movement of two objects that are relative to each other when viewed from different positions.

PARTICLE

A nonrendering dynamic point that is emitted into a scene and whose movement can be controlled by defining the forces that act on it. The main benefit of a particle is that large numbers of them can be created and emitted into a scene at the same time to simulate dust, smoke, or even flocks of birds. Even though the particle itself is nonrendering, a 3D object or texture can be associated with the particle's location frame by frame to simulate large swarms of objects or clouds of some substance.

PARTICLE SYSTEM

The term for a particle emitter and any of its emitted particles.

PHONG SHADING

A superior method of shading surfaces that computes the shading of every pixel by interpolating data from the surface normals.

PIXEL

An acronym of picture element. The smallest component of a digitally generated image, such as a single dot of light on a computer monitor. When a resolution is given, such as 1024 x 768, it refers to the number of pixels that the monitor, or the selected graphics mode, can display.

PLUGIN

A small program that "plugs in" to an application to extend its features or add support for a particular file format.

POLYGON

Any 2D shape that has three or more sides can be described as a polygon. Polygons—usually triangles, but sometimes quads—are the basic unit of all 3D applications, where they can be joined together to create the surfaces of 3D objects.

PRIMITIVE

A basic geometric element (e.g., a cylinder, pyramid, or cube) from which more complex objects can be built.

QUAD

A four-point polygon.

RAY CASTING

A simplified form of ray tracing, where the effects of direct light on a model are traced by the rendering engine, but not the actual effects of light bouncing off, or between, the surfaces.

RAY TRACING

A rendering algorithm that simulates the physical and optical properties of light rays as they reflect off a 3D model, producing realistic shadows and reflections.

REAL TIME

An operation where the computer calculates and displays the results as the user watches. Realtime rendering, for example, enables the user to move around a 3D scene or remodel objects on the screen without having to wait for the display to update.

REFRACTION

The effect where rays of light are bent, typically when passing through one medium to another, such as from air to water.

RENDERING

The process of creating a 2D image from 3D geometry to which lighting effects and surface textures have been applied.

SCALE

A 3D transformation that shrinks or enlarges an object about its axes.

SHADING

The process of filling in the polygons of a 3D model with respect to viewing angle and lighting conditions so that it resembles a solid object.

SKIN

In 3D applications, a surface that is stretched over a series of "ribs," such as an aircraft wing.

SPECULAR MAP

In many 3D applications, a specular map is a texture map—such as those created by noise filters—that is used instead of specular color to control highlights on models.

STITCHING

A technique in NURBS modeling whereby two or more surfaces are joined along their boundaries.

SUBDIVISION SURFACES

A way to subdivide polygonal objects smoothly so that they approximate the organic qualities of NURBS while retaining the inherent edibility and topology of polygons.

SURFACE

In 3D applications, the matrix of control points and line end points underlying a mapped texture or color.

SWEEP

The process of creating a 3D object by moving a 2D profile along a path.

TERRAIN

Any 3D object used to simulate the land in a 3D landscape scene. Terrains can also be specific primitive objects designed to simulate mountains and other rugged landscape objects.

TEXTURE

The surface definition of an object.

TOPOLOGY

The structure of geometric surfaces. In the case of a polygon object, its topology is said to be arbitrary—you can connect polygons in any way you like. NURBS, on the other hand, are not topologically arbitrary, but have a strictly-defined U and V structure that cannot be deviated from.

TRIANGLE

The simplest type of polygon, made from three connected vertices.

UV COORDINATES

In a 3D environment, a system of rectangular 2D coordinates that are used to apply a texture map to a 3D surface.

VERTEX

Another name for a point (polygons) or control point (NURBS).

VIEW

A window in a 3D program depicting the 3D scene from a given vantage. 3D applications have four standard views: top, right, front, and perspective.

WIND

A varying force used to affect dynamic objects such as particles or foliage.

WIREFRAME

A skeletal view of a computer-generated 3D object before the surface rendering has been applied.

Z-BUFFER

A technique that solves the problem of rendering two pixels in the same place (one in front of the other) by calculating and storing the distance of each pixel from the camera (the "z-distance") and then rendering the nearest pixel last.

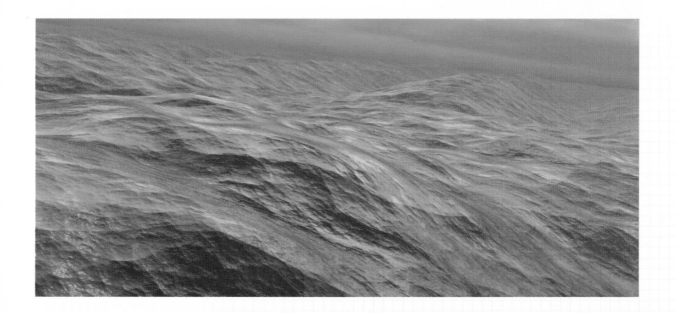

Index

A

After Effects 15, 93

animals 114, 134

animation 26, 30, 34, 36, 43

 bitmap skydome 72–73

 ocean 60–63

 ocean waves 56–59

 rain/snow 92

 stars 96

antialiasing 142–143

area light 130

artifacts 15, 25, 32, 91

ArtMatic Voyager 13, 152

aspect ratio 138

atmospherics 14, 17, 37, 65, 74–78,
 84–89, 100

B

backdrops 14–15, 34

birds 114

bitmaps 40, 42, 54, 72–73, 94

 dust/smoke 100

 finishing 140

 stars/planets 96

Boolean subtraction 120

broadband 150

Bryce 17, 20, 30–31, 64–65, 78–79

 importing objects 134–135

 lighting 94

 trees/plants 108–109

 web address 152

buildings 118, 134

C

camera-optimized terrain 26–29, 56

Cinema 4D 8–9, 22, 31–32, 39

 importing objects 134

Cinema 4D continued

 lightning 95

 lights 131

 man-made structures 119

 sky 73

 trees/plants 106–107, 109

 water 51

 Web address 152

clouds 17, 64–65, 67–68, 78–85,
 88, 98–99, 104–105

color 70, 76, 129, 139–141

Combustion 93

complex methods

 trees 110–113

 water 50–53

compositing 138–140, 143

compression 15, 150

computer games 146

constellations 97

copyright 42, 94, 106

creatures 114–117

D

3D Object Converter 135

3D programs

 applications 10–13, 134–145

 camera-optimized terrain
 26–29

 future trends 18–19

 limitations 8–9

3D Studio Max 31–32, 134,
 146–147, 149, 152

dams 118–121, 125

dawn/dusk 70, 129

Discreet 146

displacement mapping 22–24,
 35–36, 44, 50, 56–57, 95

Doom 146

download times 150

dust 100, 104–105, 117

E

E-on Software 18–19

EcoSystem 19

edge fall-off 117

Elements 140–143

Epic Software 146

explosions 98

exporting objects 30–31, 108–109,
 147–151

F

fake radiosity 124–125

file translation 135

finishing 140–145

fireworks 98

floor planes 38–39

fog 51–52, 64, 74–75, 132–133

front end editors 146

full terrain texturing 42–47

fur 114

G

galleries 152

game engines 146, 148

game landscapes 146–150

Game Pack 147

geometry 14, 34–37, 92, 95

 dust/smoke 100–101

 man-made structures 119

 radiosity 128

 trees/plants 106–107, 109

gmax 146–148, 152

ground 8

H

hair 114, 117

Half-Life 146, 148

Hammer 148

haze 64–65, 74–77, 89, 143–145

HDRI (High Dynamic Range
 Image) 53, 63, 82, 117

height maps 20–21, 24–25

HyperNURBS 9, 23, 32

hyperrealism 7

I

importing objects 134–137, 149

insects 114

Internet 32, 42, 84, 86, 94

 compositing 138

 creatures 114

 importing objects 134

 optimizing 150–151

J

JPEGs 15, 25

K

keyframing 59, 72–73

L

lighting 8, 14, 16–17, 104

 ambient 122–123

 man-made structures 121

 radiosity 126–129

 scene 124–125

 special effects 132–133

 types of light 130–131

lightning 94–95

LightWave 26–27, 32, 34–36, 56,
 62–63

LightWave continued
 planet atmosphere 84, 86–89
 trees/plants 112
 volumetric clouds 82
 waves 62–63
 Web address 152
Limb Effect 87
linear light 130

M
Mac OS X 139
man-made structures 118–121
Maya 32, 98, 109, 152
mist 74–75, 132
modding software 146–149
Mojoworld 12, 152
moon 64, 90
mountains 34–37

N
n-gons 32
night sky 96–97
NURBS 118

O
ocean 56–63

P
Paint Shop Pro 140
PAL resolution 96
parallax 15, 34, 36
parallel light 130, 133
particle systems 92, 98, 100, 103
Phelps, Nicolas 18–19
Phong shading 137
Photo-Paint 140
photorealism 7, 18, 32, 39

Photoshop 15, 42, 54, 60, 70
 compositing 138–139
 dust/smoke 101–102
 finishing 140–145
 lightning 94
 planet atmosphere 87
 sky 72
 stars/planets 96
 trees/plants 106
planets 84–89, 96–97
plants 106–113
plugins 104, 109–110, 147–148, 151–152
point light 130
polygon reduction 150–151
procedural texturing
 man-made structures 118
 planet clouds 78–79
 terrain 40–42
 trees 108–109
PSDs 141

R
radiosity 113, 123–129
rain 92–93
ray tracing 52, 60, 66, 79
realistic scene lighting 124–125
reflection 48–49, 51–53, 55, 60, 117
refraction 52
roads 118
rocks 32–33, 40
ruins 118

S
scene lighting 126, 129
shareware 135

Shockwave 151–152
simple methods
 lighting 122–123
 man-made structures 118–121
 sky 64–65
 trees 106–107
 water 48–49
sky 8, 15–17, 64–73, 90, 96
skydome 64, 66, 70–73, 96, 117, 124, 127–128
smoke 98, 100–105
snow 92–93
Softimage|XSI 146, 148–149, 152
software suppliers 152
SPD (subpolygon displacement) 24–25, 43–45
spiders 114–117
spot lights 130–133
sprites 100–105
stars 96–97
stones 32–33, 40
storms 98–100
sun 64–67, 70–72, 77, 89–91, 122, 129–130
Swift 3D 151–152

T
telephoto effects 91
terrain 14, 20–23, 149–150
 camera-optimized 26–29, 56
 full texturing 42–47
 optimizing 30–31
 procedural texturing 40–41
TGAs 141
TIFFs 22, 141
tornadoes 98–99

transparency 48–50, 60, 69, 93, 135, 140
Tree Pro 94
trees 106–113
twisters 98–99

V
Valve 148
vegetation 110
video games 146
volumetrics 16–17, 65, 69
 clouds 80–83
 haze 76–77
 lighting 132–133
 smoke 104–105
Vue Professional 10–11, 18–19
 atmospherics 74
 importing objects 134
 lightning 94
 procedural texturing 40
 scene lighting 122
 trees/plants 108–109
 Web address 152

W
water plane 48–53, 121
water vapor 74
Web addresses 96, 134–135, 149, 152
Web graphics 150–151
wetness 54–55
Windows 139
world coordinates 56, 58, 78, 80

X
X-Frog 109
XSI Mod Tool 148–149, 152

Acknowledgments

PICTURE ACKNOWLEDGMENTS

6—Painting by David Hollis

 Photograph by Steve Luck

18—*Rising Star* by Robert Czarny

 Cerro Verde by Eran Dinur

19—*War of the Worlds* and *Venus* by Robert Czarny

 Tropical Cove by Luigi Marini

 Bali by Eran Dinur

149—Images courtesy of Epic Games, Inc. www.epicgames.com

 www.unrealtechnology.com

OTHER ACKNOWLEDGMENTS

Thanks to www.mayang.com for providing many of the rock and ground images on the CD.

Thanks to Johannes Schlörb for providing many of the sky images on the CD. Johannes can be contacted at johannes@schloerb.com, and his work can be found at www.turbosquid.com/Search/Index.cfm/FuseAction/ProcessSmartSearch/istIncAuthor/JohannesSchloerb/blAuthorExact/y

Thanks also to Nicolas Phelps, Matt Riveccie, and all at E-on Software, and Perry Stacy and all at Maxon.